LAURIE SIMMONS

Walking
Talking
Lying

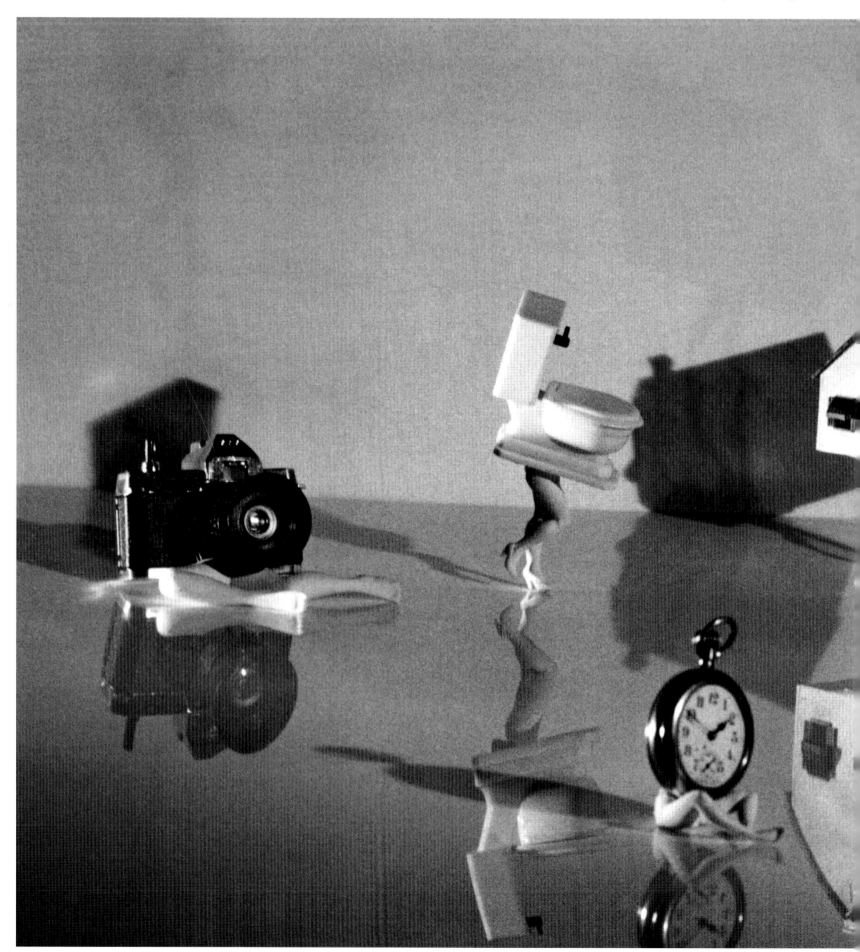

Walking, Talking, Lying

Text by Kate Linker　　aperture

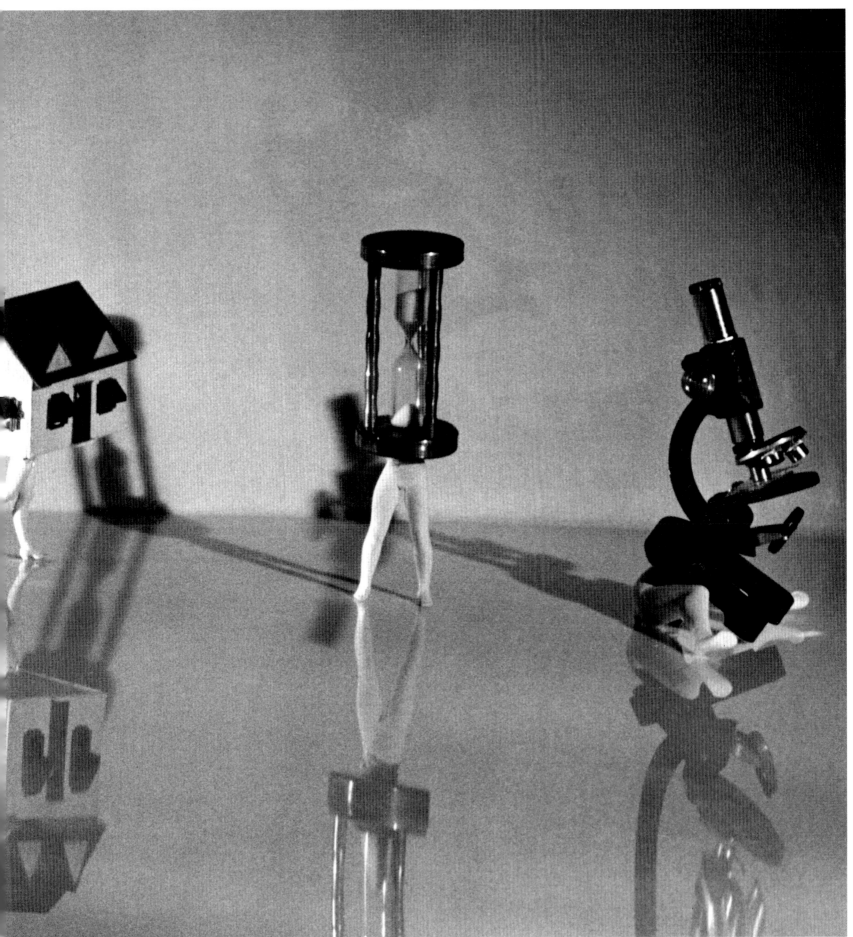

Walking, Talking, Lying　　Text by Kate Linker　　aperture

Front cover: *Long House (Red Bathroom)*, 2004. See plate 13.
Back cover: *Walking Camera I (Jimmy the Camera/Color)*, 1987. See plate 53.
Frontispiece: *Magnum Opus (The Bye-Bye)*, 1991. See plate 22.

Editor: Nancy Grubb
Designer: Francesca Richer
Production: Lisa A. Farmer

The staff for this book at Aperture Foundation includes:
Ellen S. Harris, *Executive Director*; Michael Culoso, *Director of Finance and
Administration*; Lesley A. Martin, *Executive Editor, Books*; Carmel Lyons,
Assistant Editor; Andrea Smith, *Director of Communications*; Kristian Orozco,
Director of Sales and Foreign Rights; Diana Edkins, *Director of Special Projects*;
Megumi Nagasue and Albane Sappey, *Work Scholars*

Laurie Simmons: Walking, Talking, Lying was made possible with generous support
from Melva Bucksbaum and Raymond Learsy and from the E. T. Harmax Foundation.

First edition
Printed and bound in Italy
10 9 8 7 6 5 4 3 2 1

Library of Congress Control Number: 2005922560
ISBN 1-931788-59-6

Aperture Foundation books are available
in North America through:
D.A.P./Distributed Art Publishers
155 Sixth Avenue, 2nd Floor
New York, N.Y. 10013
Phone: (212) 627-1999
Fax: (212) 627-9484

Aperture Foundation books are
distributed outside North America by:
Thames & Hudson
181A High Holborn
London WC1V 7QX
United Kingdom
Phone: + 44 20 7845 5000
Fax: + 44 20 7845 5055
Email: sales@thameshudson.co.uk

aperturefoundation
547 West 27th Street
New York, N.Y. 10001
www.aperture.org

The purpose of Aperture Foundation, a non-profit organization,
is to advance photography in all its forms and to foster the exchange
of ideas among audiences worldwide.

Contents

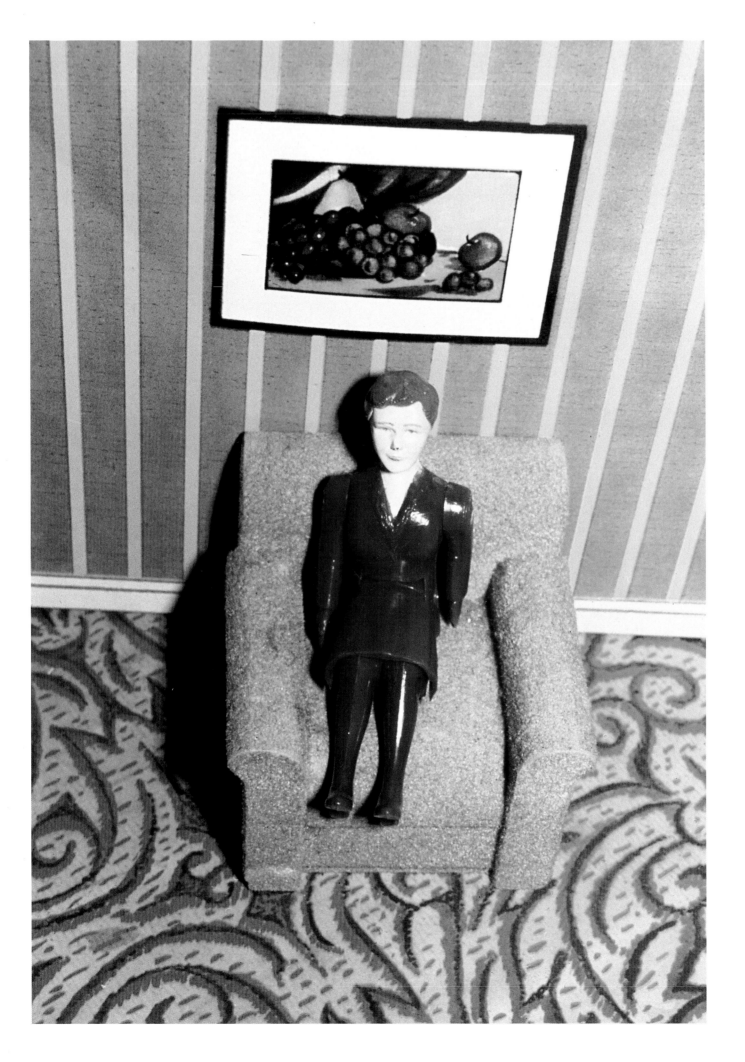

Reflections on a Mirror BY KATE LINKER

Oh, how large the world is in the brightness of the lamps!

How small it is in the eyes of recollection!

MARCEL PROUST, *The Remembrance of Things Past*

During the late 1980s Laurie Simmons began a group of photographs that question the relationships between human beings and things. The ostensible subjects of the works are objects that appear to walk, talk, sit, or lie down, as well as ventriloquists' dummies that affect a precariously illusioned humanity. Viewers respond to them with a range of emotions that touch on their often extraordinary beauty, theatricality, human pathos, and above all, uncanny strangeness. Since we know the world as a set of ordered relationships, any tangling of the imaginary lines that connect or separate human subjects and objects troubles both the coordinates and the intimate organization of our lives. However, Simmons's aim in these photographs is less to provoke than to stimulate personal and philosophical reflection. Taken as a whole, the works elucidate key themes, casting light on the dolls, surrogate figures, and domestic furnishings that typify her work and providing an interpretative lens for her total practice. Elaborated over the decade from 1987 to 1997, the works are a sustained and subtle meditation on the role of the object in postwar American culture and on the meaning of photographic experience.

Because of the irreducibly personal nature of her art, a few biographical facts

1. *Purple Woman/ Gray Chair/Green Rug/ Painting,* 1978
Cibachrome print,
5 x 3½ in.
(12.7 x 8.9 cm)

provide stepping stones for entry. Simmons, who lives and works in Manhattan, moved to New York City in 1973 shortly after graduating from the Tyler School of Art near Philadelphia. The small domestic interiors and homely vignettes in her early photographs place Simmons within a generation of artists who came of age in the 1950s and early '60s and approached photography as a conceptual and cultural medium rather than as a fine-art practice. These artists—Richard Prince, Louise Lawler, Barbara Kruger, and Sarah Charlesworth among them—inherited the photo-based conceptual practices of Ed Ruscha, Jan Dibbets, and others and applied the radical new definition of photography as a medium of discourse to the examination of social and cultural representations. For them, the postwar media expansion in television, advertising, and film had proposed new ways of understanding the world, reflecting an image world in which the predominance of technically reproduced surfaces threw into question the old, stable coordinates

2. *Woman/Red Couch/ Newspaper*, 1978
Cibachrome print,
3¹/₂ x 5 in.
(8.9 x 12.7 cm)

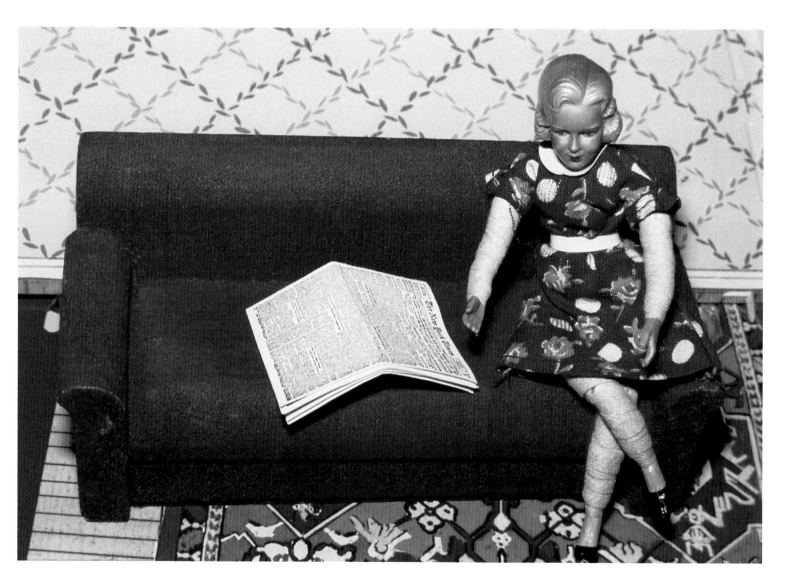

of reality. To a degree, such disembodied illusions of things supplanted the philosophical "thing-in-itself," producing a new epistemology by which images not only "counted" culturally but also constructed our views of the world. Through the sitcoms and game shows of television, the formulaic plots and characters of mainstream cinema, and the imagistic rhetoric of advertising, artists of Simmons's generation encountered ample instances of the social power of representations. Inspired by the role of the camera in the postwar world, many artists examined these conventionalized representations in staged photographic tableaux, centering on the domestic interior and its customary inhabitants, the nuclear family.

Simmons's earliest works are photographs of miniature spaces that the artist constructed in her loft, using dollhouse furniture, objects, and wallpaper that she found in several old stores in upstate New York.[1] Rudimentary forays with a camera following a traditional art school training, the photographs were executed with the guidance of a friend, the photographer Jimmy DeSana. In them, the objects and the patterned wallpaper build up a scenographic representation of domestic space. In works like *Purple Woman/Gray Chair/Green Rug/Painting* (1978; plate 1); *Woman/Red Couch/Newspaper* (1978; plate 2); and the stunning Bathroom series from 1976, 1978, and 1979 (plate 15), distortions of scale, angled planes, and traceries of light from invisible or illogical sources accentuate the visual artifice. In some works, small female figures clothed in the severe suits and shirtwaist dresses of the late 1940s and early '50s stand or sit, staring forlornly into space. The photographs that depict figures follow the interiors chronologically, but all of these tiny works share the same sense of suspended time and pervasive sadness. The critic and curator Carol Squiers has remarked on their "tender and melancholy" quality, observing that Simmons's approach to her domestic subject matter was unique: "Her use and manipulation of miniaturized dolls, objects, and interiors gave the photographs the abstracted quality of a dream, which was markedly different from the cool, pseudo-documentary images of other artists."[2] Simmons has described these works as "the recreation of a sense of visual memory or history," reproducing "a feeling, a mood, from the time that I was growing up."[3] The context that they evoke is the 1950s and the new archetype of American life, suburbia, that Simmons knew from her childhood on Long Island.

Simmons's work is a deceptively simple response to a complex transformation in American culture centered on the increasing importance of objects. The postwar period produced a new model of experience—suburban life—and a new mandate—consumer style—reflected in the gleaming surfaces, profuse patterns, and distinctive materials of the products that contributed to the period ambience. The two decades after World War II coincided with the rise of a middle-class culture based on acquisition and consumption that was motored by an economic boom.

At first, Americans simply made up for their frugal renunciations during the Depression and the war; the period from 1946 to 1954, as Thomas Hine has written, "produced a lot of cars, a lot of babies, a lot of appliances, a lot of suburbs."[4] But soon a powerful consumer economy was stimulating an orgy of production, purchasing, and exhibition. The display of objects, or what later was called "conspicuous consumption," became a modus operandi for a generation that conceived of objects not only instrumentally, but also symbolically. As more and more choices entered the marketplace, the purchase of attractive, designed, or "stylish" objects replaced the older focus on useful or functional things. Americans were starting to view objects "as part of a way of life rather than as tools for carrying out a particular task."[5] What one "had" or possessed became an important signifier of status within the newly important economic and social category of the middle class.

The composed quality of Simmons's early work, with its tidy living-room ensembles, nursery wallpaper, and gleaming bathtubs and sinks, reflects the new attention being paid to the home. This attention is documented in actual patterns of acquisition. Studies of consumption show that during the mid-'50s, "family budgets began to be expended differently: outlays on food, clothing, and lodging dropped significantly while expenditure on the household . . . , leisure, transportation, and culture rose. Even in relatively backward countries and across all classes, there was a convergence of purchases around a standard set of household equipment, from indoor toilets to the most recent commodity on the market, namely, television."[6] New spatial typologies were being invented—the "recreation room" and "den," for example—but the furnishings in them were conventionally predictable. Living-room suites, lounge chairs and recliners, stuffed armchairs with ottomans, "side tables," dining tables with four, six, or eight matching chairs, and television "consoles" became standard items, along with the appliances— the dishwasher foremost among them—that populated now-fashionable dine-in kitchens. Simmons's early interiors, from 1976–78, present variations on the theme of the suburban home. Jan Howard has suggested that the multiple rearrangements in the 1978–79 Black Series (plate 5), in particular, were inspired by the systemic formulas of Hanne Darboven, Sol LeWitt, and other Conceptual artists.[7] In Simmons's works from this period, a limited repertory of furniture— chair and ottoman, sofa, TV, end table; or, alternatively, sink, bathtub, and toilet— reappears, altered by the rearrangement of walls and objects, or beginning in 1978, by solid-color or patterned surfaces shot in the newly available Cibachrome film. Here, an exotic rug; there, a swatch of striped wallpaper; elsewhere, the clash of patterns where the yellow and gray stripes cloaking one plane meet with another surface covered with green-and-yellow garlands. The images pop with a burst of visual sparkle, then subside into convention. Framed paintings of nearly identical

3. *Rabbit Shape*, 1978
Cibachrome print,
3½ x 5 in.
(8.9 x 12.7 cm)

still lifes hang on the walls behind chairs or sofas in some photographs. Elsewhere, photographic reproductions of scenic views simulate the "window on the world" of the popular picture window. Although these works demonstrate Simmons's neophyte efforts to construct roomlike spaces, they also suggest the illusions of multiplicity that can be achieved through the visual calculus of style. Hine notes that, in 1957, "one average-sized furniture manufacturer offered twenty different styles of standard sofas, three styles of sectionals, eighteen styles of love seats and thirty-nine upholstered chairs, each available in seventeen different qualities of fabric, each available in a dozen or more colors or patterns. You could buy anything you wanted, as long as it was conventional."[8]

An image from a series of small black-and-white photographs dated 1976

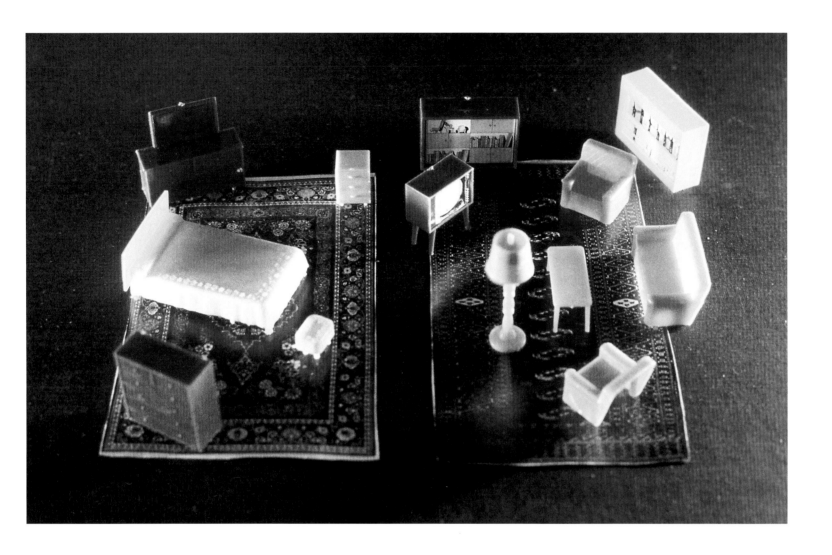

suggests the philosophical weight of the domestic object in the new suburban environment. In it, a female doll attempts to lift a dining-room chair using a toy tow truck (plate 6). The chair is physically out of scale with the truck, which in turn is conceptually ill-suited to the job at hand. Nevertheless, the chair occupies the symbolic center of the visual pyramid formed by the opposing diagonals of the woman's bent body and the tow-truck pulley. Other images in the series continue the narrative, showing the woman as she attempts to sit on the chair (still suspended from the pulley; plate 7), then falls off and lies disconsolately on the ground (plate 8). This miniature drama suggests that the domestic object in these '50s interiors is no longer a simple tool but rather a symbol of social aspirations and, in consequence, a source of frequent frustration.

Longing and desire displaced onto objects and environments figure throughout Simmons's oeuvre. Other photographs from the 1970s display tight and even claustrophobic spaces constructed by the disposition of domestic objects. A female

doll, obviously a housewife and inevitably alone, inhabits space uneasily, framed by the clutter of her possessions. Time seems eerily still, despite an etiolated, ambient light that turns domestic environments into visual spectacles. Lynne Tillman, whose stories and novels play on similar suburban conventions, has described this diffused time in *Haunted Houses*: "The days passed. The nights passed. Time disappeared as she stared at her own reflection in windows and mirrors. She lay in the sun for hours, with nothing on her mind, nothing that she could account for later."[9] As in Tillman's narratives, the rooms in Simmons's images are metaphors for psychological spaces through which a female inhabitant tenuously threads her way. Howard notes that the figure moves through these environments "as if the doll were an actress creating frames for a stop-action film."[10]

The 1950s spawned interest in the discipline of sociology, and a key concept was the social presentation of the self. The idea that things stand for their owners motivated the dialectic of acquisition and display, with the result that mass-produced but stylized goods increasingly served as a kind of personal "identity kit."[11] Behind their acquisition lay a fundamental faith in the eloquence of objects, in their ability to speak for the human subject.[12] Simmons addressed this process of self-accreditation in 1990–92 in a group of sculptures ironically titled Clothes Make the Man. Each sculpture consists of an identical male dummy differentiated only by the clothes he wears. Simmons's use of the dummy—a literal "thing"—expresses the tension between the self as object (looked at and evaluated on the basis of visual evidence) and the self as subject (defined through human relationships). In the domestic environment the idea of self-accreditation gave rise to a view of the home as a symbol of self. The result is that the middle-class house of the 1950s, with all its furniture and appliances, appeared more and more to be "a credential as well as a haven,"[13] as Joan Kron has written in her study of the psychology of interior design. The possession of objects increasingly signified inclusion in the Good Life. Since objects were standardized and hence similar, attention shifted to their surfaces, opening up territory that could be massaged by marketing and exploited by advertising. Superficial appearance—the look of things—was becoming equal to or more important than real substance.

Perhaps the best analyst of product suasion is Stuart Ewen, whose *All-Consuming Images: The Politics of Style in Contemporary Culture* (1987) traces the elaboration of this surface eloquence. Although Ewen covers the gamut of modern marketing, he dwells on the 1950s' suburban consumer revolution as prototypical of the new influence exerted by objects on American lives.[14] For him, the key process was disembodiment, the separation of surface from substance that allowed the *appearance* of things to acquire an independent and dominating force. The paradigm of such disembodiment is, of course, the photograph, and Ewen singles

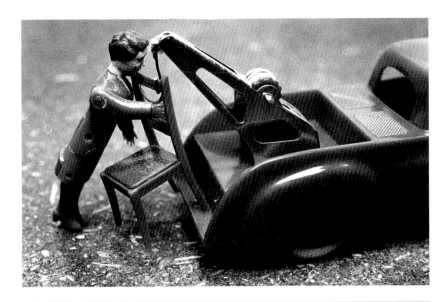

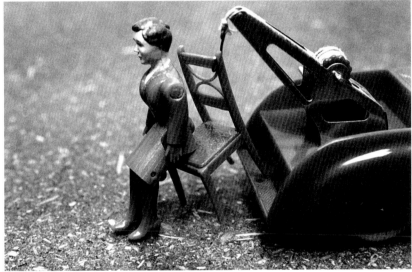

TOP TO BOTTOM:
6. *Woman Lifting Chair/
Tow Truck*, 1976
Gelatin silver print,
5¼ x 8 in.
(13.5 x 21 cm)

7. *Sitting in Chair/
Tow Truck*, 1976
Gelatin silver print,
5¼ x 8 in.
(13.5 x 21 cm)

8. *Falling Off Chair*, 1976
Gelatin silver print,
5¼ x 8 in.
(13.5 x 21 cm)

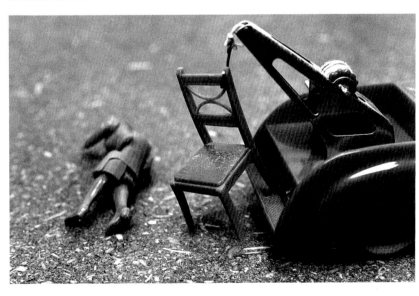

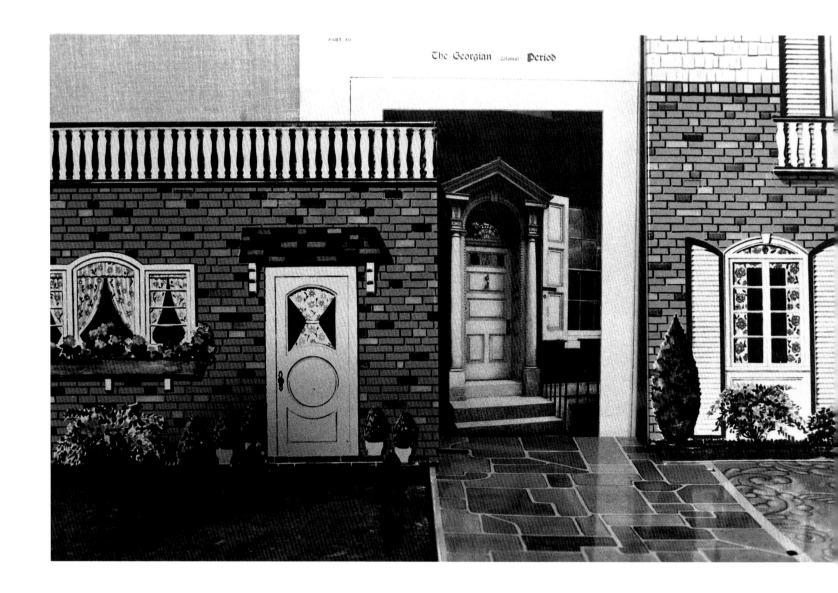

out the nineteenth-century man of letters Oliver Wendell Holmes as a major figure in predicting the social power of photography. The oracle Ewen cites, however, is not the well-known eulogist of the "mirror with a memory," but rather the Holmes who in three articles from 1869 accurately foresaw the traffic in surfaces and "skins" that would follow photography's invention. On one hand, Holmes wrote, photography signaled the onset of an era when the "image would become more important than the object itself, and would in fact make the object disposable."[15] On the other hand, the photographic split of "form" from matter also prefigured the importance of style or design, inasmuch as "matter as a visible object is of no great use any longer, *except as the mould on which form is shaped.*" [Italics mine] In such disembodiment Holmes predicted the beginning of a market in images that would maximize the gap between outside appearance and inner substance:

9. *Dollhouse Facade,* 1976
Gelatin silver print,
5¼ x 8 in.
(13.5 x 21 cm)

"We have got the fruit of creation now, and need not trouble ourselves with the core. Every conceivable object of Nature and Art will soon scale off its surface for us. Men will hunt all curious, beautiful, grand objects, as they hunt cattle in South America, for their skins and leave the carcasses of little worth."[16] Despite his mixed metaphors, Holmes not only pointed the way toward the reign of images in postwar society but also forecast the remarkable plasticity with which style would wrap itself around the contours of objects that were increasingly of little functional value. The allure of surfaces as well as their split from the "core" function of things would become a truism of contemporary life. Few nineteenth-century writers more accurately predicted the collapse of the truth-telling capacities of the photograph than Holmes.

The alternative reality provided by this photographic paradigm is evident throughout Simmons's art, and no other artist of her generation has more deeply examined its broad social and cultural implications. To start with architecture: a black-and-white photograph, *Dollhouse Facade* (1976; plate 9), shows the "skin" of a house as a collage of different styles. Georgian-period pediments, French windows, half-windows with café curtains, and balustraded balconies, among other elements, coexist with the dominant surface materials of brick, slate, and wood. These decontextualized elements reflect the 1950s' unapologetic endorsement of veneers and aesthetic flourishes, both inside and outside the home.[17] Wood grain and other Formica, vinyl, Con-Tact paper, and ApliKay were among the new decorative surfaces that allowed a potential infinity of illusions—blatant lies—to spring forth from blank or neutral grounds.[18] Con-Tact paper alone could make virtually any surface look like something else. Simmons's Instant Decorator series, 2001–4, based on a 1970s decorating manual, exhibits the same impulse to achieve multiple styles or "looks" from a single plan. Similarly, the mass-produced dollhouses that she designed with the architect Peter Wheelwright under the trademark Kaleidoscope House (2000) employ as their model the shifting planes and dizzying visual effects of the eponymous toy (plate 10). (The dollhouse facade also makes use of modern architecture's technologically profound separation of skin from frame in the so-called curtain wall.)

Most characteristic of the suburban houseowner's experience, however, was the standard developer's house. Multiple styles and variants to a basic floor plan were available, offering the illusion of "custom" homes.[19] Among the styles to be chosen were Cape Cod, ranch, English Tudor, and colonial, soon joined by "California contemporary." Options included stone facing, shutters, cupolas, porticos, L-shaped layouts, front doors with classical motifs, and carports or garages for the now-essential car. Sliding doors, flagstone patios, and "picture windows" looking out over carefully tended gardens and lawns were common features. Many

of these architectural elements appear in Simmons's 1998 *White House/Green Lawn* (plate 11). Inside, the owners' choices among myriad floor and wall coverings, furniture finishes and fabrics, and the latest appliances played still more variations on the basic scheme. As Ewen has observed, echoing *Dollhouse Facade*, "the indiscriminate collage of disembodied images applied a thin, if playful, facade of individuality to an essentially conformist environment."[20] Everything reflected the view that consumption was a form of self-expression. The names of the emerging shelter magazines, *Better Homes and Gardens* and *House Beautiful* among them, were verbal semaphores of the new Good Life.

The separation of surface from substance or core allowed products to be personalized or adapted according to fantasy or whim. Without anticipating Simmons's anthropomorphic objects of the late 1980s, it suffices to mention here that style encouraged the confusion between objects and bodies. For example, in the 1950s and early '60s, cars were redesigned according to anthropomorphic models; Raymond Loewy reconceived the Coca-Cola bottle in a svelte, "feminized" form; and Madison Avenue gurus spoke with increasing frequency about "products with personalities."[21] More and more, objects took on nonobjective capabilities: magazines of the 1950s and '60s often referred to appliances as "servants" or "conveniences"[22] as they carried out activities once performed by human labor. They acquired "subjective qualities,"[23] appearing through the lens of advertising as sexy, perky, powerful, friendly, hard-working, and so on. The change marks a philosophical as well as psychological shift in the stature of objects. Thus, in a collection of stories significantly titled *The Safety of Objects*, A. M. Homes describes how "cars with fathers coming home from work pulled into driveways,"[24] hence subverting the customary authority of the individual. Similarly, dolls not only represented idealized humans; women, increasingly objectified, were often seen as dolls, as when men spoke familiarly of an attractive woman as "a real doll."

Simmons has described the environment of her 1950s childhood as "both beautiful and lethal." Loneliness and emptiness recur in descriptions of a world in which facades covered over inner feelings and thoughts. This was particularly true for women. Television and magazine advertising from the '50s portrays women much as in Simmons's images—always modishly but improbably dressed, perpetually vacuuming in high heels, at once mistresses of a domestic universe and subject to it. As Victoria de Grazia has written, '50s women appeared as "the proverbial shoppers, the *Ur*decorators, the perennial custodians of the bric-a-brac of daily life."[25] Surrounded by newly capable and humanized objects, women often seemed to do little. Although Simmons avoids a simple feminist interpretation of her art, noting that it re-creates the psychological spaces of her childhood,[26] her work nevertheless resounds with period intimations of emptiness. In a series of almost

10. *Kaleidoscope House #8*, 2000
Flex print,
24 x 16 in.
(61 x 40.6 cm)

impossibly lovely interiors from 1982–83 (plate 12), Simmons posed bright-colored monochrome dolls against color-coordinated backgrounds, so that the dolls seem to merge with their environments. ("Fading into the woodwork" was a common domestic fear in the 1950s.) In many of her domestic scenes from the mid- to late 1970s, the dense array of bric-a-brac threatens to engulf the female inhabitant. The theme of uniformity beneath apparent diversity also informs the clothing of Simmons's figures; multiple colors and fabrics vary a restricted reper-tory of conventional styles—shirtwaists, tailored suits, twin sets.[27] Style provides an attractive otherness, a cloak over the emptiness of uniformity.

The importance of applied appearance runs through contemporary diction: women "put their faces on" with makeup in the morning, and many felt "un-dressed"—uncovered or naked—without lipstick. A series of small color photo-

11. *White House/Green Lawn (View IV)*, 1998
Cibachrome print,
20 x 30 in.
(50.8 x 76.2 cm)

graphs by Simmons dated 1979 constructs a mini-narrative of a single woman confronting and pushing an oversized lipstick that stands—upright and unsheathed— on a domestic floor (plate 14). The series shares stylistic and thematic qualities with the black-and-white photographs of the tow truck produced some three years earlier. Here, the encounter is color-coded: the vivid red of the make-up—so-called lipstick red—matches the background of the woman's floral-printed dress. Although the object is physically oversized, its scale is psychologically commensurate with the new demands of artifice and surface embellishment. Few viewers will miss the lipstick's phallic shape or the sexual connotations of the gesture by which the woman tenderly grasps its "hips." Alternatively, the overscaled background of the flowered wallpaper constructs a primitive drama between nature and culture in which culture, in the form of man-made artifice, wins out. Spotlights, compressed planes, and the reduction of unnecessary details establish the atmosphere of a stage space. The photographs are at once theatrical and symbolic—a moral narrative for a materialistic age.

A staged quality permeates Simmons's work, from its themes, ambience, and specifically theatrical allusions to the directorial nature and direction of her working methods. In conversation, Simmons often speaks about the theatrical quality of her childhood, in which everything appeared as if readied for a performance or event.[28] Her published descriptions of her childhood home, referred to as "11 Strathmore Road," are loving renditions of a place that was transformed through décor into a kind of stage for human activities. Her words also delineate the kind of hazy conundrums of light that stimulate moody imaginings in a solitary child. To Simmons, this suburban home represents the "first home," the one to which we return in memory, the archetype of generalized nostalgia and remembered "homeliness."

In *In and Around the House: Photographs 1976–78*,[29] Simmons comments that a description of her house makes it "sound almost like theater," despite its tasteful appointments. She depicts the Tudor-style structure as a tribute to her mother's decorating talents, dwelling on the gender-coded bedrooms, tiled bathrooms, tinted mullioned windows, and time-and-space-traveling appurtenances—a cuckoo clock from Switzerland, a Moroccan leather settee, a Japanese bar in the living room. Most impressive might be the basement recreation room intended for parties that was "finished to look like an old-fashioned soda shop." Small white tables, chairs with heart-shaped backs, striped café curtains, and a Formica-coated bar surmounted by shelves holding "apothecary jars filled with gumdrops and peppermints" were only some of the room's features. A wall covered with "white painted chunks of wood made to look like brick" attested to the period love for simulated surfaces. It is unclear whether the room is a refuge for relaxing or a performance

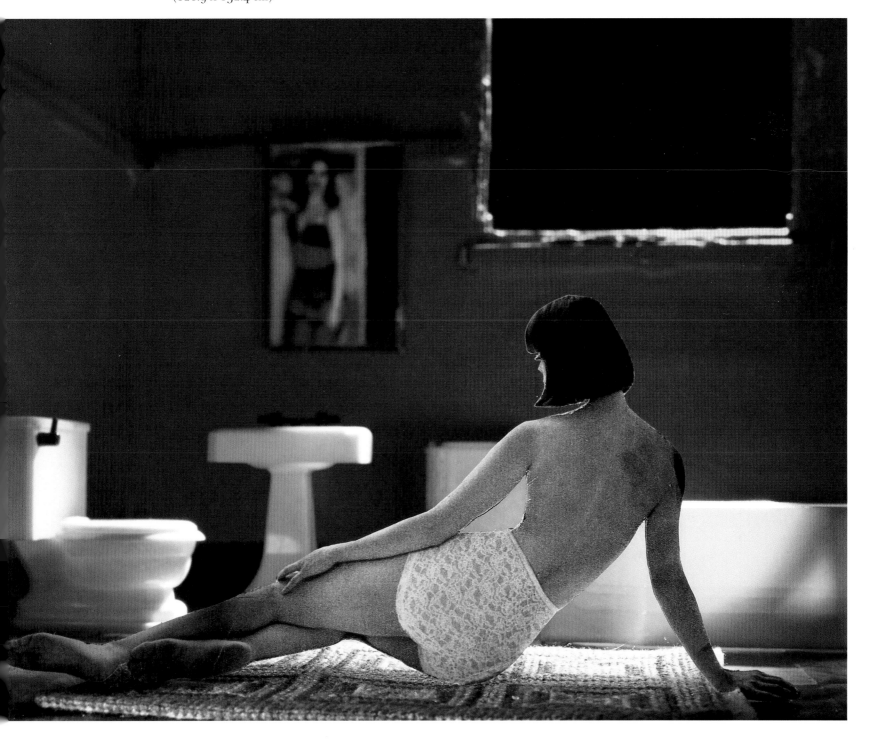

space. The carefully crafted space with its multitude of details recalls the performance spaces that were represented daily on TV.

Simmons's use of the theatrical tableau, though hardly uncommon in her generation,[30] is still unusual in its consistency and intensity. Nevertheless, during the 1950s and early '60s all of the camera-based arts, including television, advertising, and film, seemed to converge on the same fundamentally theatrical model of space. The suburban vision of contemporary life arrived in the late 1940s with the widespread acquisition of TV, when families rearranged their living rooms around television sets, transforming them into mini-theaters of mass-cultural transmission. What they got, of course, were visions of themselves, played back in a shallow, theatrical space against the backdrop of kitchens, living rooms, and so on. The same spatial context and structure appear in sitcoms like *The Adventures of Ozzie and Harriet* or *Leave It to Beaver* and in television advertising, in which new consumer products—often anthropomorphized, like Mr. Clean—appeared as if they were actors in the drama of contemporary life. Actual theatrical stages, often with live audiences, were used for popular talent or variety shows like *Jackie Gleason* and *Lawrence Welk*; in game or theme shows like *Candid Camera*; and in the dance routines in the Fred Astaire or Busby Berkeley movies broadcast on television. Elsewhere, real life echoed the representation: little girls like Simmons took ballet or piano lessons, participating in recitals where parents watched their children perform. The world, it seemed, was a stage—or at least a recordable spectacle. The detached view that transmuted both individuals and objects into images was echoed in the framed images produced by the cameras that flooded the postwar market.

The inherent spectacle of Simmons's art also relies on two fixtures from photographic history—the picture magazine and the snapshot. During the 1950s, oversized picture magazines like *Life* and *Look* presented figures posed against the backdrop of contemporary life, as if in scenes excerpted from an ongoing narrative. *Life*'s weekly presentation of the world as a sort of national family album of people, places, and events impressed Simmons, who pored over issues in her father's dental office. In the Fake Fashion (1984–85) and Tourism (1983–84) series, Simmons posed her models and female dolls similarly—in the first, against rear-projected images of apocryphal settings (plate 16); in the latter, against tourist views of world-famous monuments. The world as representation, seen and experienced through images, was a modern-day paradigm for the Kodak generation, and Tourism, in particular, presents an armchair, *Life*-like, souvenir tour of architectural history. Much like the Kodak slogan that promised to tell us the stories of our lives, these photographs all have an implicit narrative. However, these images are even more connected to the family pictures taken by Simmons's

OPPOSITE, TOP:
14. *Pushing Lipstick (Full Profile)*, 1979
Cibachrome print,
5¾ x 8¾ in.
(14.6 x 22.2 cm)

OPPOSITE, BOTTOM:
15. *New Bathroom/Woman Standing/Sunlight*, 1979
Cibachrome print,
3½ x 5 in.
(8.9 x 12.7 cm)

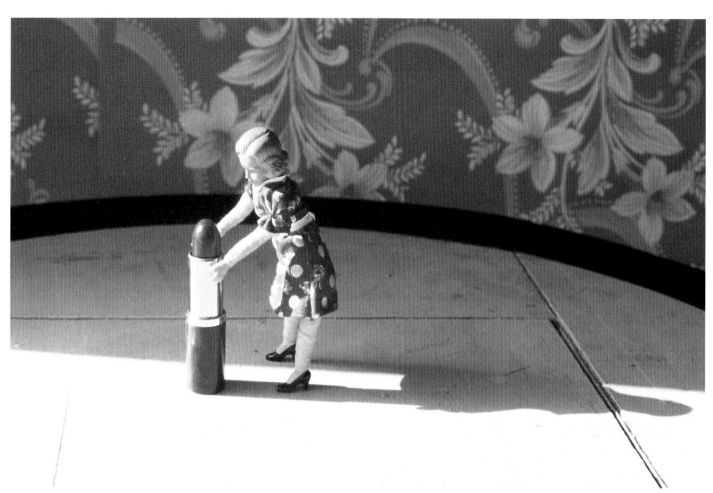

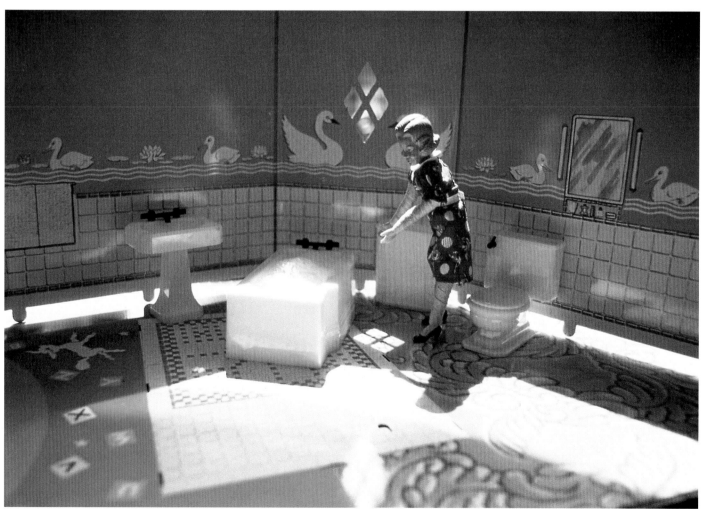

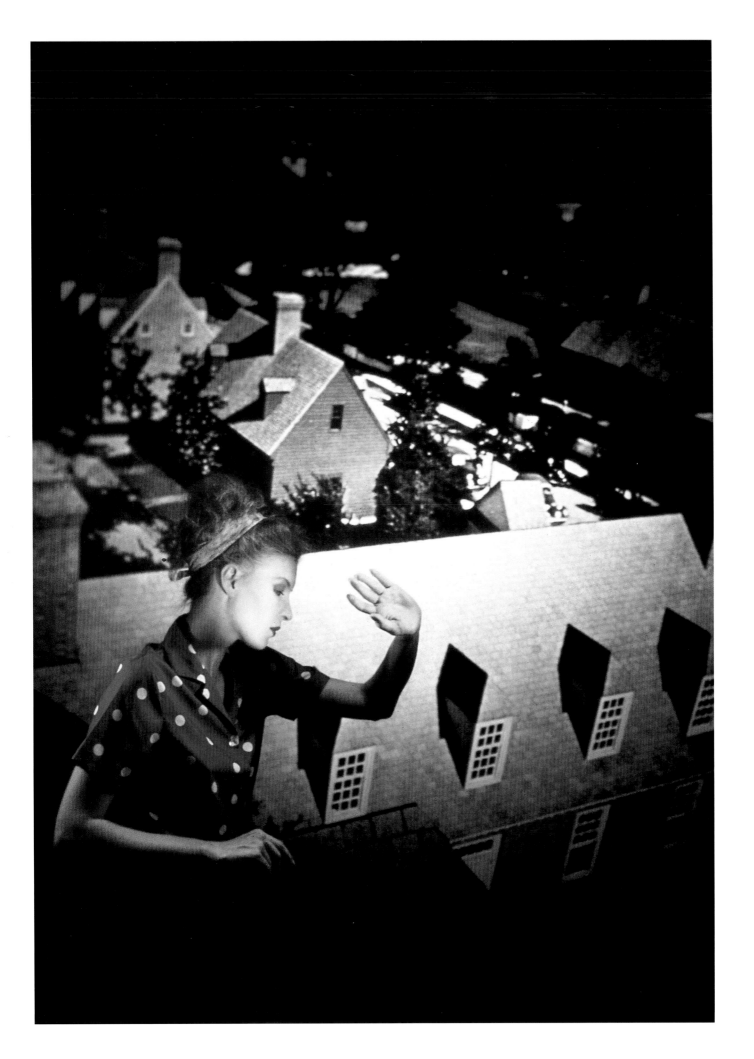

father, in which he meticulously posed his subjects against their backgrounds so as to produce both a centered image and a framed view.

Simmons cites her father as a major influence on her photography, and many of his family pictures show a formal and compositional sophistication that her stilled narratives and theatrical portraits repeat. Her father also kept current with developments in photo technology and gave his daughter a Brownie camera when she was six, replacing it when improved versions came out. Photographs from the family album show the young Simmons, her Brownie suspended from a strap around her neck, in a variety of situations. Throughout these pictures, her father's camera displays a characteristic equanimity, addressing everything and everyone— Simmons, her sisters, the neighbors, the Brownie, a clown doll, a ventriloquist's dummy—with its equalizing gaze. In one photograph from 1956 we see Simmons, again with her camera, posing with two young neighbors against the background of their home. Parallel planes arranged in shallow depth construct the space of the image, extending from the implied place of the photographer through the line of figures and ending in the wood siding (and inevitable picture window) of the suburban house behind them. The forced composure of the participants— "Smile! You're on Candid Camera!" "Cheese!"—transcribes the process by which the camera transforms people into disembodied surfaces, images.

Throughout her career Simmons has made pictures of picturing. These include both photographic portraits with major roles (for example, *Walking Camera I [Jimmy the Camera]*, plates 21 and 53; *Magnum Opus [The Bye-Bye]*, plate 22) and smaller "cameo" appearances in verbal texts. The written works center on sites of remembered importance that betray similarities to the "first home." For example, in *In and Around the House*, Simmons describes a visit to her father's dental office and basement darkroom. This is heaven to a five-year-old:

I remember childhood days where I seemed to make my own schedule, and I often chose to sit in my father's waiting room, reading and rereading the oversized, mostly black-and-white picture magazines. . . . What I really waited for was a chance to follow my father down to our basement to a tiny darkroom off of a dank laundry area, where he developed dental X-rays. I would crouch on the floor under the counter and watch my father's huge white shoes turn pale orange when he switched on the safe light. Sometimes he would pick me up so I could see the ghostly forms of molars come to life on the black film.[31]

Simmons evokes an essential illusionism from which objects and events emerge, transformed, as "ghostly" presences in the "other" world of images. As a child, she watched magic shows on television, and the same "Presto!" sense of wonder comes through in her work. A small black-and-white photograph from 1976, *Big Camera/ Little Camera* (plate 17), is a portrait of a real camera and its tiny surrogate—a

16. *Rooftop*, 1984
Cibachrome print,
60 x 42½ in.
(152.4 x 108 cm)

toy, miniature, or model. Although the difference in size calls up period allusions (mother/daughter, tall/small, the children's book characters Fred and Ted, and so on), the picture is most probably "about" scale. Simmons's photograph presents two objects—one real and "actual-size," the other its miniature analogue—that are re-presented as equal on the plane of the image. The play with scale in the image suggests the "scale dislocations" so admired by the artist, who has described herself as always "awestruck by what [she] saw through the viewfinder."[32] Photography appears as a false mirror, and it is the doubleness or duplicity of the camera that transports Simmons, much like Alice, through the looking glass of the viewfinder.

Simmons's invocation of memory and evocations of the past recall the writing of Marcel Proust, and Howard, among others, has referred to *Remembrance of Things Past* in interpreting her art. Both Proustian nostalgia and a fundamentally literary quality distinguish Simmons's work, as Squiers intimated, from the more intellectual practices of her peers. For example, much photo-based art of the

17. *Big Camera/ Little Camera*, 1976
Gelatin silver print,
5¼ x 8 in.
(13.5 x 21 cm)

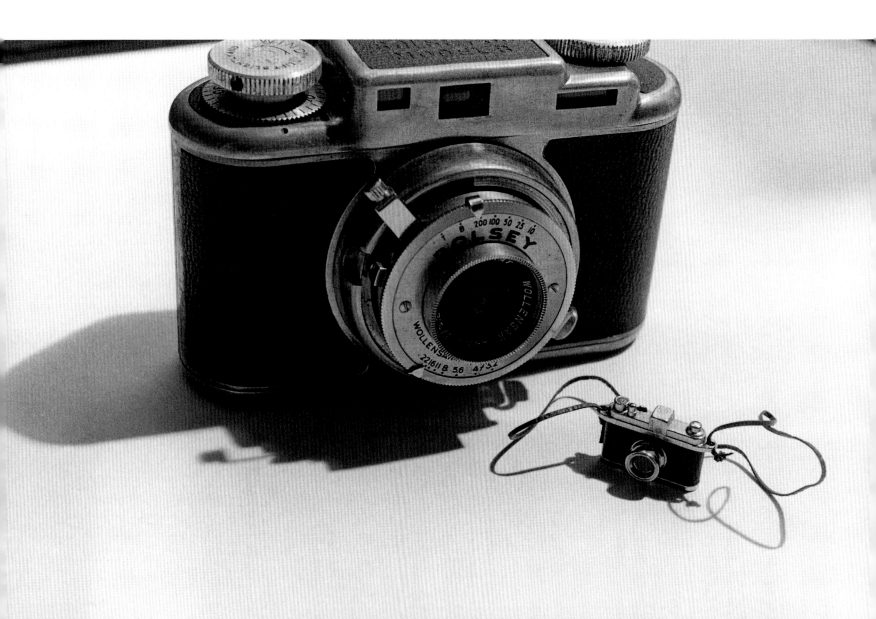

1970s and '80s was informed by the "period influences" of Jean Baudrillard, Walter Benjamin, and Roland Barthes, and allusions to these philosophers and intellectuals, among others, abound in the artists' work. Such references are nowhere evident in Simmons's oeuvre. Instead, the key interpretative lens through which to view her art may be Benjamin's short tribute to the role of time and memory in Proust's seven-volume novel. Although Proust's novel belongs to the nineteenth century, its echoes in Simmons's art are salient.

Titled "The Image of Proust,"[33] Benjamin's text encapsulates key aspects of the author's work, dwelling on its pervasive melancholy, its propensity for artifice, and the role of visual images in the elucidation of memory. Benjamin makes much of the "sadness" or "homesickness" of Proust's work, which he rightly characterizes as an "elegiac form" crafted by one haunted by "the incurable imperfection in the very essence of the present moment." It is the relentless search for "the original, the first happiness" that instigates the reveries Proust spins out of his childhood world in Combray. Second, Benjamin observes that although *Remembrance of Things Past* is an autobiographical novel, it is based on the "discrepancy between literature and life." Proust, he remarks, did not describe an actual life, but rather "a life as it was remembered by the one who had lived it." What separates the experienced event from the one remembered is the split between the finite nature of lived experience and the infinite elaborations of recollection, which conceal as much as they reveal. Most important, however, Benjamin dwells on the immanence of the visual in Proust, observing that "most memories that we search for come to us as visual images." Others have noted Proust's predilection for metaphors taken from the field of optics, either in the form of instruments that produce light or visual effects, or optical devices through which the world can be seen and interpreted.[34] Lenses, kaleidoscopes, magic lanterns, windows, and cinematographs fall within these images, and many have parallels in Simmons's art. It is *through* such images, Benjamin writes, that "the true surrealist face of existence breaks through." However, Benjamin also observes that, in his relentless sounding of the interior world of memory, "Proust could not get his fill of emptying the dummy, his self, . . . [in search of] the image which satisfied his curiosity." These rhetorical figures—dummies, images, and objects—articulate the world of Simmons's art from 1987–97.

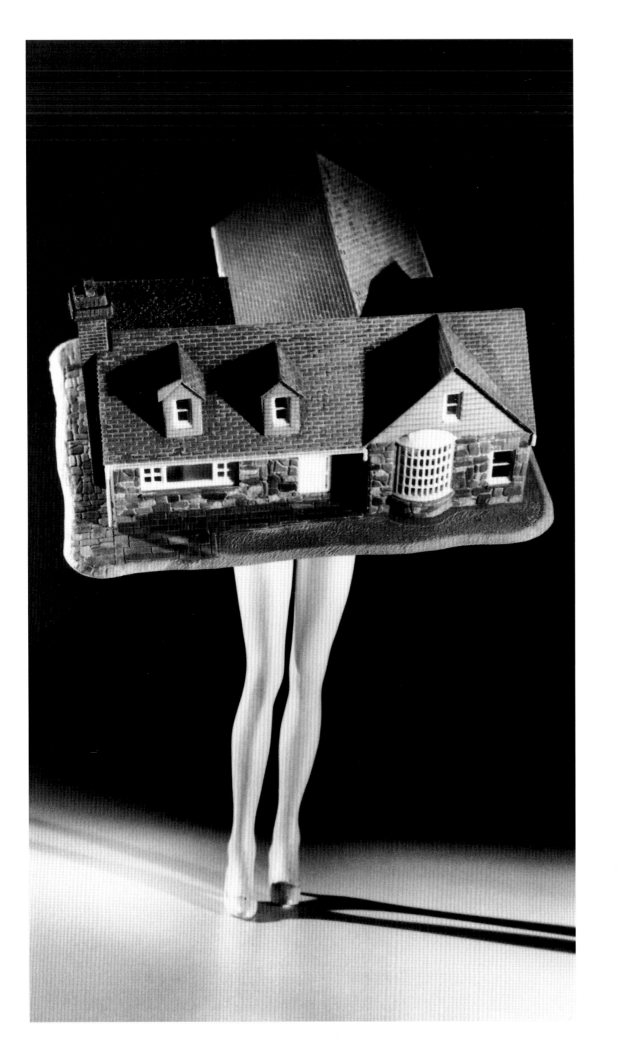

Grace, like most children, took stories to heart.

She waited up nights, a captive to the secret lives of her dolls,

and feared they might say terrible things about her. . . .

In a way she never gave up the notion that her dolls came alive.

LYNNE TILLMAN, *Haunted Houses*

On Saturday mornings in the late 1980s, around the time that Simmons was beginning to make her Walking and Lying Objects, children and their parents were being regaled by the televised antics of Pee-wee Herman. A variation on popular but less imaginative children's programs such as *Mr. Rogers' Neighborhood* and *Captain Kangaroo*, *Pee-wee's Playhouse* proposed a domestic space in thrall to the power of objects. Inanimate objects transformed into characters called "Chairry," "Globey," and so forth held court with a puppet, a talking cow ("The Cowntess"), and the brilliantly wacky Herman in a surrealistic hijacking of daily life. Simmons's friend and colleague, the artist Barbara Kruger, described *Pee-wee's Playhouse* in her monthly column, "TV Guides," as a "zanily serious love affair with domestic interiors."[35] Other shows also transformed animals into characters (as in the saccharine *Care Bears* series), but Herman's spectacle was unique in embodying our cultural obsession with objects. *Pee-wee's Playhouse*, Kruger wrote, "shows the actual displacement of caring from people to objects as the motor that makes the world go round. . . . The playhouse is a domain where *things*, from bikes to knickknacks to appliances, reign supreme. Human beings are *garni*, little extras that brighten up the room."

18. *Walking House*, 1989
Gelatin silver print,
84 x 48 in.
(213.4 x 121.9 cm)

Such anthropomorphic antics, however, merely repeated other, more basic metamorphoses that had been performed in 1950s and early '60s television. Scheduling included, among other features, children's programs, talent shows, and variety formats with live bands. In most cases commercial product advertising was integrated into the programming, making the '50s a "Golden Age" for television advertising. The programs of the period were designed to be watched by kids and parents together, giving advertisers a new tool for marketing goods within the growing consumer culture. Complementing the programs were family-oriented advertising campaigns aimed at convincing viewers of the virtues of consumption. Many programs were subsidized or uniquely sponsored by manufacturers, often from the tobacco industry, reflecting a time before health hazards impinged on the American Dream.

To a child of the '50s, the names of these programs function like Proustian madeleines, conjuring up the naive but magical world of early television. For children, there was *The Magic Clown*, which pushed Bonomo's Turkish Taffy; *The Howdy Doody Show*, with the eponymous marionette, Clarabell, and Buffalo Bob Smith; and *Andy's Gang*, hosted by Andy Devine along with his inimitable puppet, Froggy. Later on came shows like *The Mickey Mouse Club*, with bands, club-show motifs, and to-this-day memorable theme songs. Everybody watched the Cleaver family on *Leave It to Beaver* and *The Donna Reed Show*, while parents, in particular, turned on *The Jack Benny Program* or *The Jackie Gleason Show*. *The Ed Sullivan Show*, with its band and performers, attracted a general spectatorship, as did Arthur Godfrey's shows. Long before *American Idol*, many singers, dancers, jugglers, impersonators, and so forth got their start on *Ted Mack's Original Amateur Hour*. Among them was the ventriloquist Paul Winchell, whose dummy, Jerry Mahoney, was an inspiration for Simmons's Ventriloquism series and appears in toy form with the artist in family snapshots.

Using figures and themes from popular culture helped coat television commercials in seductive entertainment. In search of memorable images for a compelling brand identity,[36] advertisers turned to specific marketing strategies—association with celebrities and anthropomorphism chief among them. The first profited from the growing popularity of specific actors and performers. Bert Lahr worked for Lay's Potato Chips, while Jean Arthur promoted Jello; Jimmy Durante and Milton Berle became spokesmen for Kellogg's Cornflakes and Pepsi-Cola, respectively. But the most powerful commercials of the period used the new technology of screen animation, featuring anthropomorphic animals or objects that seemed to spring to life. Thus, Tony the Tiger encouraged the Texaco user to "Put a Tiger in Your Tank," while Ipana toothpaste became identified with the brush-wielding beaver, Bucky. Lucky Strike ads featured square-dancing cigarettes;

19. *Walking Cake I (Color)*, 1989
Cibachrome print,
84 x 48 in.
(213.4 x 121.9 cm)

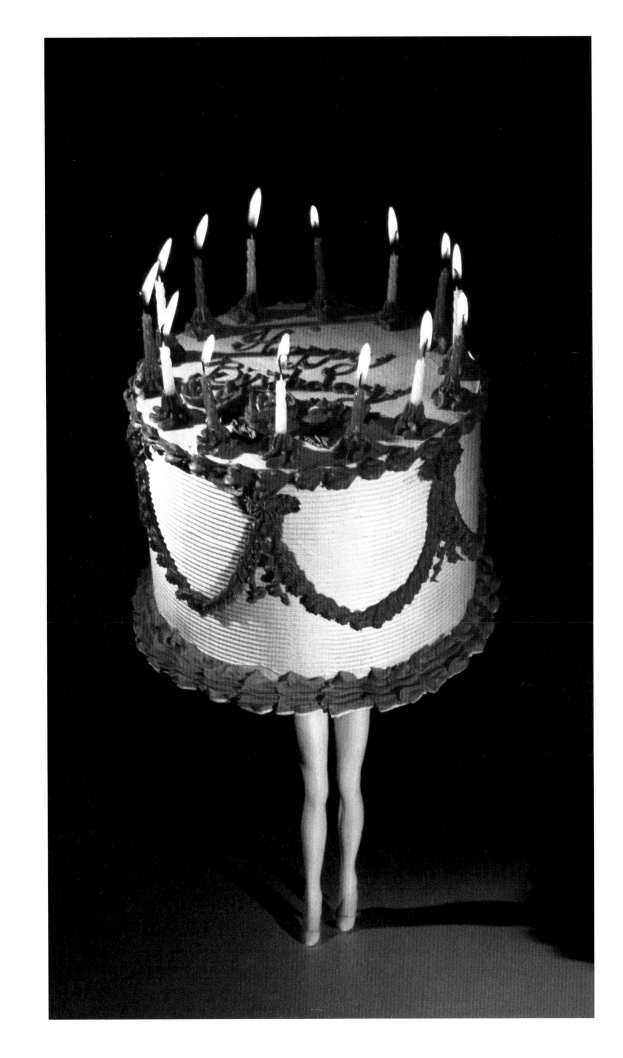

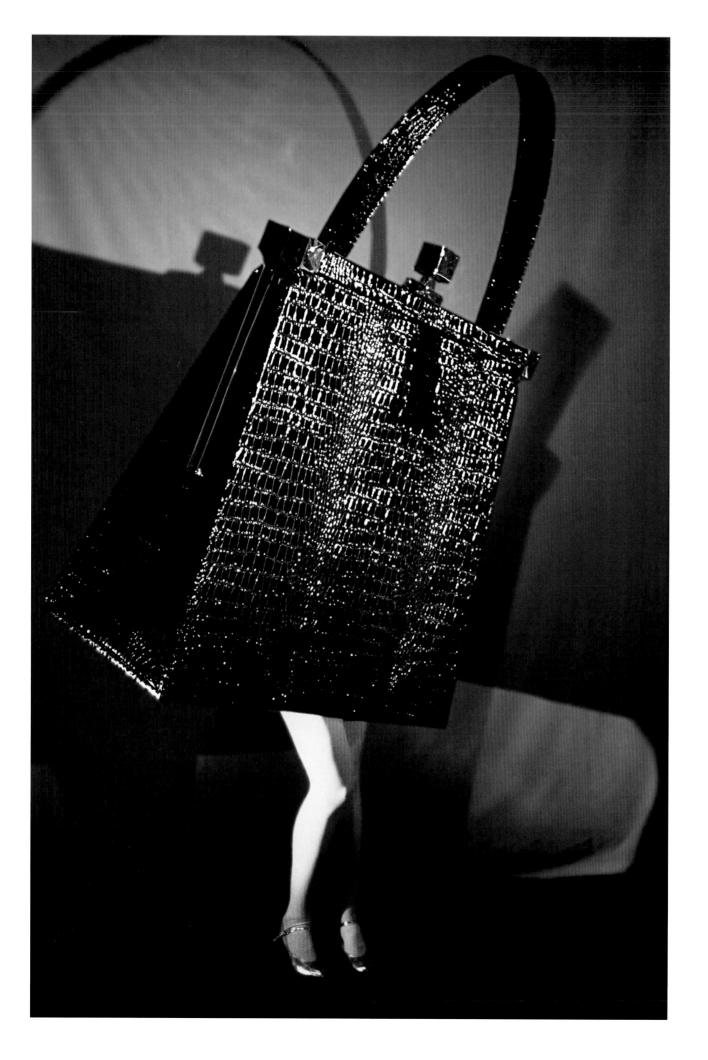

Kool cigarettes, skating penguins; and Rheingold Beer organized a parade with a marching band of bottles and cans of beer. Every viewer knew Chiquita Banana, the anthropomorphic fruit, and many of us still sing her little jingle in the quiet space of memory. A beloved icon from the period was Muriel, the dancing cigar, who closed her performance for Muriel's Cigars with a sexy tag line ("Why don't you pick me up and smoke me sometime?"). But by far the most memorable commercial was the clip of dancing cigarette packets and matchboxes that Old Gold cigarettes produced in 1949. The ad featured long-limbed female models dressed in boxy, oversized costumes, who tap danced across the stage to a branded dance-hall tune. Viewers of the period came to know them by name as well as by their "characters," "Little Matchbox," "Regular," and "King Size." Promotional stills show the figures theatrically spotlit against a blue curtain, their costumes revealing only beautiful, sexy legs. The commercial ran frequently between segments of *The Original Amateur Hour* (which Old Gold sponsored), as well as on quiz shows. Simmons recognizes the commercial as a source for the Walking Objects, which she began in 1987.

The first Walking Objects involved oversized props posed on human legs, and their dancing figures, stilled by Simmons's camera, owe much to Old Gold's inspiration. Here is Simmons on film, discussing her source:

> *I had seen when I was a child a TV show in the fifties where there were dancing cigarette boxes and dancing matchboxes and it always stayed with me as a kind of image of something that was so physical, without a brain, without a heart, without a mind—but maybe something just about joyousness and gleefulness and fun. Those ideas spawned the image of the camera on legs and from there it just seemed like there were a number of creatures I could make.*[37]

The artist's implied opposition of physicality and mind, or what she elsewhere calls "brawn" and "brain,"[38] suggests a distinction between these works and the more talkative, "brainy" ventriloquist series that chronologically precedes them. However, both the Walking Objects and the related Lying Objects are complex artifacts that allude to numerous sources. Among them is Surrealism, understood both generally, as in Benjamin's reference, and specifically, as a literary and artistic movement. Inspired by Comte de Lautreamont's fantastic couplings as well as by Salvador Dalí's metamorphoses, Surrealist hybrid objects and images were intended to disorient their viewers and to problematize "objective" categories. Examples relevant to Simmons's Objects include a gramophone "trumpet" projecting female legs[39] and Man Ray's photographic portrait, *Le Violon d'Ingres*, of a woman's body as a musical instrument. Both suggest that women are instruments to be played on by male fantasy—a fundamentally misogynistic notion, characteristic of Surrealism, that was later refuted by such Surrealism-inspired women artists as Louise

20. *Walking Purse (Color)*, 1989
Cibachrome print,
64 x 46 in.
(162.6 x 116.8 cm)

Bourgeois. Jan Howard has cited Bourgeois's 1947 drawing, *Femme/Maison—To Carletto* as a possible model for Simmons's *Walking House* (1989; plates 18 and 62), in which a domestic icon—a typical suburban home—provides a metaphor for (feminine) psychological space. Morphological parallels also link *Lying Perfume Bottle* (1990; plate 52) to the similarly long and threatening form of Bourgeois's 1969 sculpture, *Femme Couteau*, which demolishes the Surrealist notion of woman-as-instrument or muse.

Readers of children's literature will also find parallels to Baba Yaga, the witch with the magic house on chicken legs in Russian fairy tales; to Humpty Dumpty; or to the personified playing cards in *Alice in Wonderland*, among others. But the Objects also recall more pervasive feelings of loneliness and longing behind the common childhood desire to make inanimate possessions come alive. In conversation with Sarah Charlesworth, Simmons has described children "figuring out if their toys can speak, or finding a face in some object and making it talk," remarking that this process is "about softening the condition of loneliness and making friends out of thin air."[40] In this manner, children project alternative identities onto surfaces, imaginatively painting a man's face on the moon to warm the eerie coldness of the night sky or, like Ludwig Bemelmans's Madeline, projecting the familiar shape of a rabbit onto the cracked and eroded surface of the ceiling. Adults extend such empathetic projection onto objects in consumption. Such allusions resonate in the Walking and Lying Objects, yet none of them exhausts the meanings of these prodigiously inventive works.

Much like the Old Gold commercial, the first Walking Objects were shot using live models dressed in tights, dancers' shoes, and oversized costumes, who danced or paraded around the simulated stage in Simmons's studio. Later photographs in the series employed toy figures and surrogate models. The "live" works include *Walking Camera I (Jimmy the Camera)* (1987; plates 21 and 53) and *Walking Purse* (1989; plates 20 and 51). The prints are large—almost seven by four feet—and, like the ensuing Objects, their hybrid subjects are human-scale and were photographed with spotlights crafting dramatic plays of shadow and light. Although the size of the images encourages the viewer's identification with these equivocal portraits, their stagy presence and spotlit theatricality detach them from the viewer's space. The result is that the objects become iconic presences.

The model for *Jimmy the Camera* was Simmons's friend Jimmy DeSana. He was dying at the time, and the image is a touching tribute to a photographic mentor. DeSana leans forward deferentially, seeming to bow quietly as he prepares to exit the stage. A figurative as well as a literal photographic embodiment, the image gives physical form to the creative and illusionary power that Simmons found in the camera. The hulking presence of the box camera alludes to an early period

21. *Walking Camera I (Jimmy the Camera/ Black and White)*, 1987 Gelatin silver print, 84 x 48 in. (213.4 x 121.9 cm)

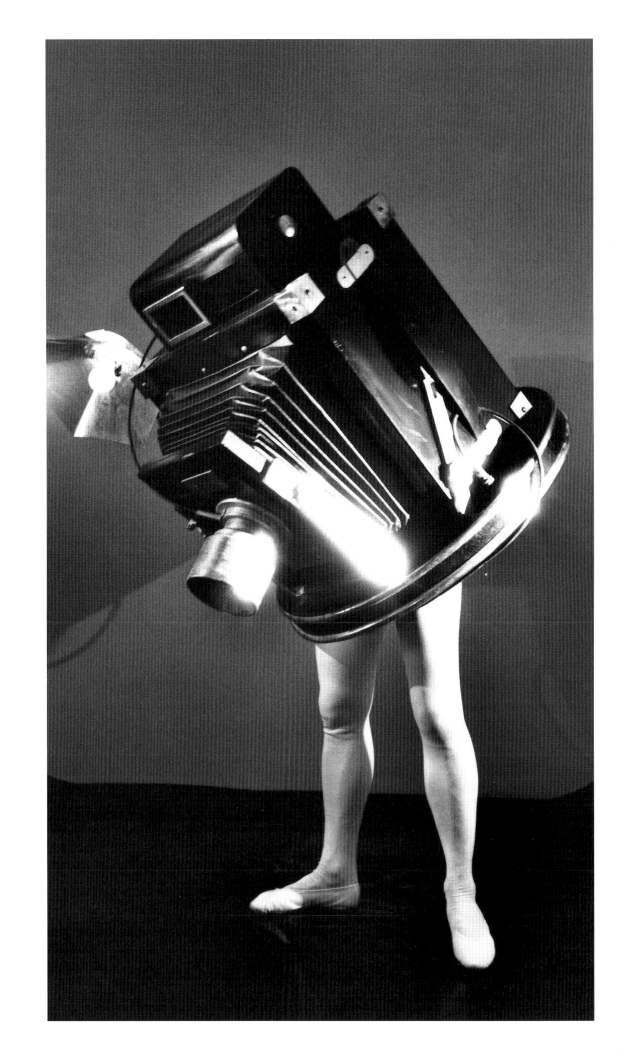

of photographic history. The feeling of the image is dark, moody, and enigmatic. Shimmering light in the foreground draws attention to the lens of the camera, setting up parallels between the camera's "eye," DeSana's vision, and the "I" of Simmons's authorial subjectivity.

Simmons has described her work of the late 1980s as concerned with "superficiality, . . . with the confusion between ourselves and our possessions."[41] Throughout the decade the theme of consumption recurs in work by such feminist artists as Judith Barry, Martha Rosler, and Kruger. Few images better depict the consumer's use of things to represent the self, or fill a void, than *Walking Purse*. The oversized alligator handbag that the artist had built for the shoot simulates the kind of luxury item found today in attic closets or vintage clothing shops. Posed on stockinged female legs shod in glittering tap shoes, the subject appears as the consummate shopper and consumer. Among the Objects this work veers closest to the spirit of 1950s commercials, but it would be wrong to limit its interpretation to playful nostalgia. Closer inspection reveals that the subject totters on timidly placed legs, while its cast shadow looms ominously in the background. With the Objects series, shadows assume increasing importance, and their darkness and frequent distortion lend noir overtones to the interpretation of woman-as-object. Here, the handbag conceals as much as it reveals; like the later *Walking House*, it provides an image of interior or psychological space. In this embodiment of conspicuous consumption, the woman presents an opulent veneer to the outside world while remaining closed off—isolated and withdrawn—inside. The clasp at the top of the purse, which sparkles like the lens in *Walking Camera I*, accentuates this sense of imposed closure.

Shortly after making *Walking Purse*, Simmons turned from oversized objects and human models to miniature or life-size objects on doll-size or diminutive artificial legs. *Walking Cake* (1989; plates 19 and 61) is a transitional image that began with a large manufactured "costume" and ended in a traditional baker's display cake attached to artificial legs. The legs for the series were chosen from dolls, tiny figurines, or, in *Bending Globe* (1991; plate 59), Japanese modeling kits with metal body parts attached by tiny chains. The abstraction and scale of the dolls and other elements allowed Simmons to play, in particular, with conventional typologies of women.

Several works play on the conflation of sexuality, meaning, and language, using verbal innuendoes to confront clichéd views of feminine sexuality. Among them are photographs that address the use of saccharine, "confectionary" diction about women. Thus, *Walking Cake* presents a woman as peripatetic "cheesecake" while the *Four Petits-Fours (Studies for Walking Cake)*, also 1989 (plates 63–66), suggest the

diminutive term *cupcake*, which is sometimes applied to little girls. Both hint at the salacious implications of women viewed as decorative objects of male visual delectation (i.e., "sugar," "eye candy," "looking good enough to eat," and so on). Simmons's use of a conventional hourglass, complete with glass and sifting sand (*Walking Hourglass*, 1989; plate 54) implies both the hourglass figure typically admired by men and the limited time available to women. (In Simmons's art, time always appears as if threatened or "running out.") *Walking Toilet* (1989; plate 58) gives a visual form to "dirty language" or "bathroom talk." In the Walking and Lying Objects, the false cover of the image provides Simmons her own authorial cover to address these issues and, hence, to avoid responsibility for them. In *Walking Gun* (1991; plate 60) the "killer woman" of film noir emerges as Simmons's juxtaposition of a toy pistol and long slender legs transforms the handle into a shapely strapless dress.

Throughout the series, showgirl routines, starlet poses, and other conventions of feminine theatrical display are deployed to address women's social and cultural roles. Through a paradox, the animation of objects becomes a means to address the objectification of women. For example, *Walking House* suggests women's association with and confinement to the home, using a conventional suburban developer's house, replete with gables, picture window, stone facing, and so on, to focus on women as both decorators and decorative objects. Elsewhere, Simmons confronts conventions from popular culture or art history (the recumbent or supine female in *Lying Perfume Bottle*; woman-as-instrument in *Sitting Accordion*, 1991, plate 56); or from pornographic representations (*Bending Globe*). The spotlight of the theatrical stage shines a light on the world stage. The construction of feminine beauty for the masculine gaze is illuminated, deconstructed, savaged. Everything seems oddly, eerily familiar.

Magnum Opus (The Bye-Bye) (plate 22) has been discussed as a play on the masculine "big" or "major" work,[42] but it is better seen as the "Big One," a recuperation of the theatrical notion of the finale. Its subtitle rehearses the simpering patter of showgirls. Simmons's working habit has been to focus her energy on the final entry in a series, as if exhausting all possibilities before moving on to new territory, and the scale, scope, and technical virtuosity of *Magnum Opus* embody this kind of summation. Nevertheless, *Magnum Opus* also breaks new ground for Simmons in its subjects and objects of discourse. A work of enormous size, *Magnum Opus* stretches some twenty feet long and eight and a half feet tall. It features six walking or sitting objects that disport themselves on now-customary female legs against a background formed by the interface of a neutral wall and a mirrored floor. The floor approximates the kind of mirrored surface sometimes found on old dressing tables or vanities. Two of the objects—a walking toilet and

a walking hourglass—are recognizable from earlier works; Simmons has added a "new" house, a camera, a microscope, and a watch or clock. These objects cast dark shadows that complicate an already intricate field of illusions. However, the most significant new feature in *Magnum Opus* is the play of reflections that the mirrored surface affords.

The six objects establish a complex framework of allusions. The objects can be grouped in three distinct domains. The walking toilet and the walking house fall within the "domestic" category and occupy the rear center of the photograph. Although these two objects contain interesting features—for example, the gables and awnings of the house-form look like eyebrows and eyes, lending near-perfect anthropomorphism to the object—they are of less significance in *Magnum Opus* than the objects in the other categories. The camera, microscope, hourglass, and watch fall within the range of optical and temporal objects or, to put it more concisely, instruments of vision and temporality. These two categories delineate the major axes of Simmons's work, which, broadly sketched, concerns time's fusion with vision in the illusions of memory. In *Magnum Opus*, the catoptrics of shadows and mirrors create complex illusions that hint at larger truths. Because of the way Simmons has located her forms, most of the action takes place in the imaginary or reflective sector of the mirror. This location visually removes objects from the realm of photographic "fact"—the sphere of real objects in tangible space—and repositions them as "fiction." Thus, the intersection of the "real" watch and the "illusional" domestic references of toilet and house creates a secondary portrait of time whiled away in nostalgic longing for the first or original home. This illusory play with portraiture is also implicit in the shadow of the hourglass conjoined with the actual house or, at the center of the photograph, in the complex, utterly irrational fusion of the mirror images of the two objects. Some of the illusions are tautological. For example, the "dirty" toilet reflects itself, creating a perverse replication and amalgam of doll limbs that is worthy of the Surrealist artist Hans Bellmer. By and large, however, the effect is less funhouse than philosophical theater. Situated at either end of the photograph, the camera and the microscope (which incorporate lenses or modalities of focus and refraction) both frame the composition and provide a key to its interpretation: *Magnum Opus* is an allegory on photography as an art of illusory surfaces that calls into question our carefully constructed categories—fact and fiction, reality and illusion, subject and object.

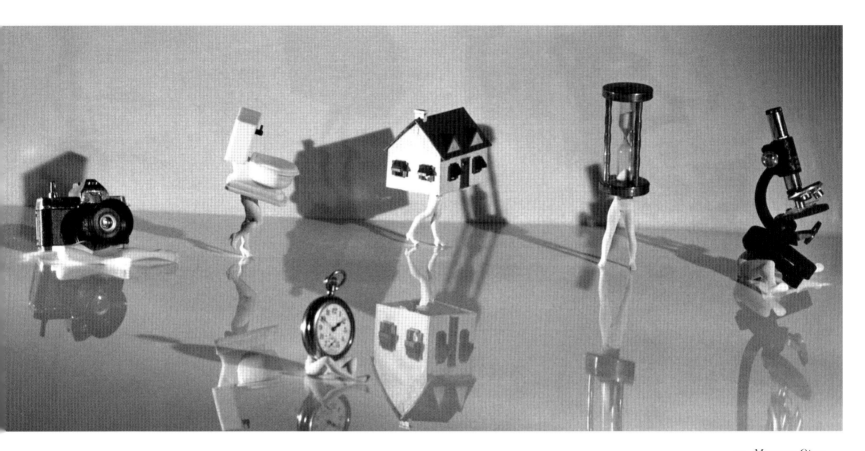

22. *Magnum Opus*
(The Bye-Bye), 1991
Gelatin silver print,
8 ft. 5 in. x 20 ft. 1 in.
(25.6 x 61.2 m)

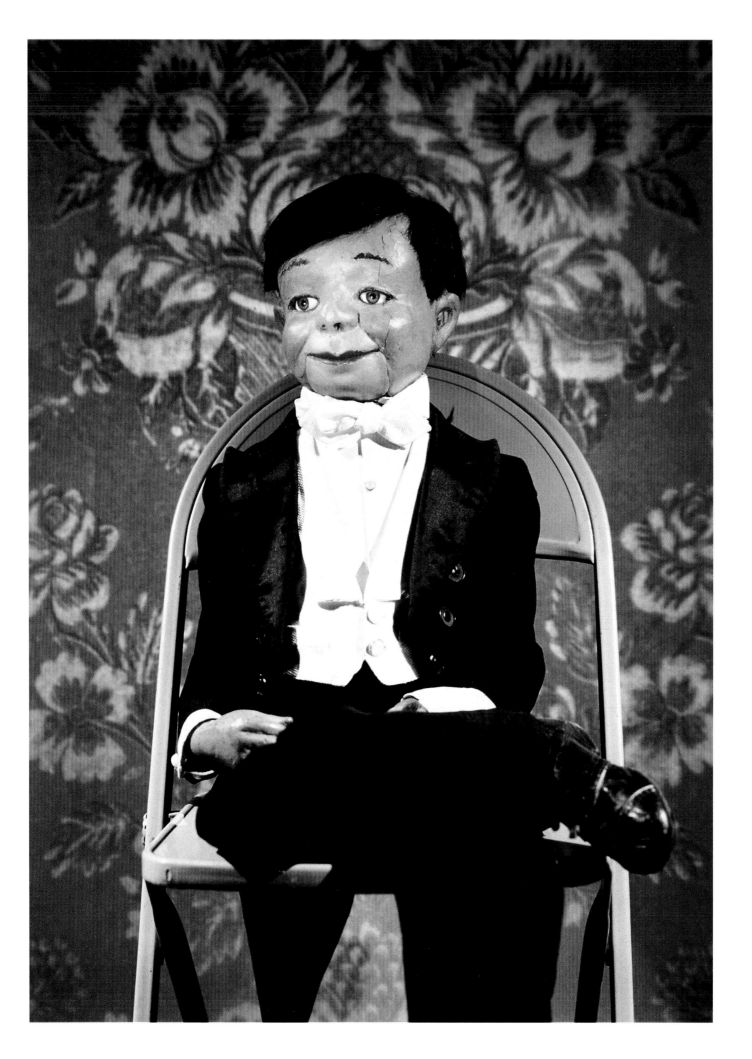

Ventriloquist: What particular branch of art are you studying now?

Boy: How to talk and renounce my words.

Ventriloquist: How to pronounce your words.

Boy: I'm ahead of the other kids.

From "A Saucy Lad: An Original Dialogue for

Ventriloquist with 'Little Boy' Figure," 1901

The confusion between individuals and their possessions is only one manifestation of Simmons's attention to ambiguous states. She has commented on her interest in this "gray area" where humans and objects appear only barely separated from one another. In her 1992 interview, Charlesworth remarked on the appeal of the equivocal: "You toy with the idea of human—almost human, not quite human, a little too human. You like to get close to this human/inhuman idea, to confuse the difference between the two."[43] A clear indication of this predilection is Simmons's work, starting in 1986, with ventriloquists' dummies, which, technically speaking, are silent objects that appear to talk. Nevertheless, ventriloquists typically downplay the object-ness of their dummies by referring to them as "figures." Although the Ventriloquism series predates the Walking and Lying Objects, its concern with the ambiguities of the figure continues, in different forms, into Simmons's work of the late 1990s and beyond.

23. *The Frenchman (Mickey)*, 1987
Cibachrome print,
35 x 25 in.
(88.9 x 63.5 cm)

Ventriloquism appealed to Simmons as a child. Early photographs show her with her Jerry Mahoney dummy; she played ventriloquist games with friends and eagerly watched the performances of Paul Winchell and Mahoney on TV. The popularity of televised ventriloquism, which extended from the late 1940s through

the '60s, rehearsed the star status accorded in the 1930s to the weekly radio shows by Edgar Bergen and his dummy, Charlie McCarthy. Winchell, in fact, had gotten his start in the late 1930s doing a Bergen/McCarthy impersonation on *The Major Bowes Amateur Hour*. Like Bergen, who had a second sidekick, Mortimer Snerd, Winchell did prime-time routines with both Mahoney and Knucklehead Smiff on NBC's *Paul Winchell-Jerry Mahoney Show*. By the mid-'60s (perhaps too late for Simmons), Winchell had conquered the kid audience with a Saturday morning program, *Winchell-Mahoney Time*, featuring a club-show motif, theme songs, and a band. Other memorable television ventriloquists include the great female vent, Shari Lewis, who performed with the puppet Lamb Chop, and Señor Wences, who worked the stage with Pedro, the Head-in-a-Box.

Although ventriloquism has long been associated with dummies (and defined by the historian Steven Connor as "the art of making certain kinds of visible anthropomorphic objects appear to talk"[44]), the use of dummies emerged only in the nineteenth century. Before that, and afterward, other objects have been used to suggest the disembodied vocalization or projection that is characteristic of ventriloquism. Examples include sphinxes and other oracles; the talking mitts, walking sticks, hats, and other props that appear in Simmons's photographs of 1987–89; and the ghostly talking jars in Samuel Beckett's plays. The alliance of a ventriloquist with a single dummy, characteristically a brash young male, became common only around the 1880s. At first this character type was merely a convenience, providing easy on- and off-stage transportation, without elaborate stage sets, for the music-hall and vaudeville routines that were becoming frequent in the late nineteenth century. Soon, however, there developed a new focus, as described by Connor, on "the ventriloquist in dialogue with his twin or *alter ego*."[45] Performances increasingly concentrated on the psychological as well as the verbal exchange, as the vent "attempt[ed] to subdue and control his insubordinate and often infantile other."[46] Although the dummy appeared to be the double of the ventriloquist (whose voice and thought were "thrown" or projected through him), his physical as well as ontological separateness insured that the ventriloquist need not take responsibility for his speech. Wisecracking, vulgarity, profanity, and lying are among the manifestations of this juvenile id, and all appear as references in Simmons's art.

Simmons's photographs from this period depict the ventriloqual dummy as a complex artifact. On one level, the staged magic of ventriloquism depends on the separation of sound from its source. Through the dummy, ventriloquism projects a voice that seems without origin or author—one that appears to be coming from some other person or place, certainly not from the impassive face and closed lips of the ventriloquist. The thrown voices of ventriloquism thus repeat

OPPOSITE, LEFT:
24. *Talking Walking Stick (Female)*, 1987
Cibachrome print,
64 x 48 in.
(162.6 x 121.9 cm)

OPPOSITE, RIGHT:
25. *Talking Walking Stick (Male)*, 1987
Cibachrome print,
64 x 48 in.
(162.6 x 121.9 cm)

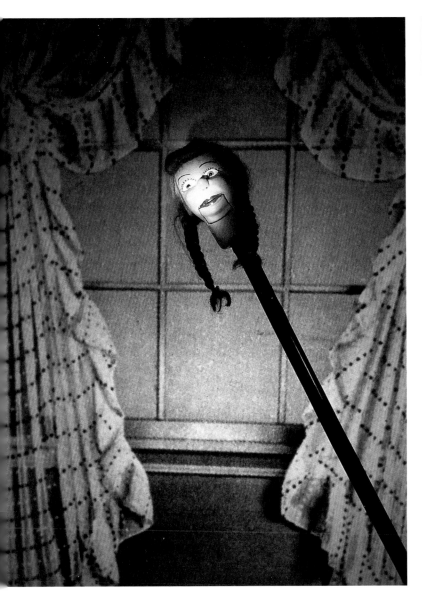

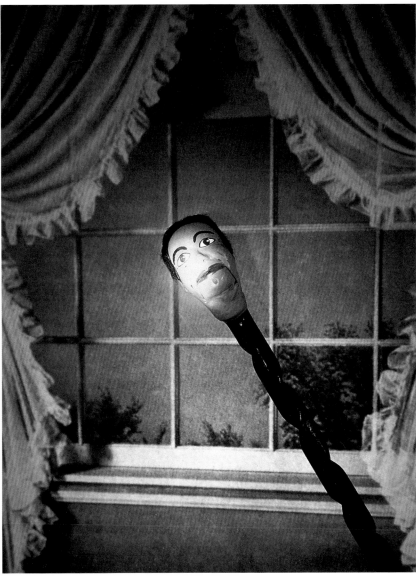

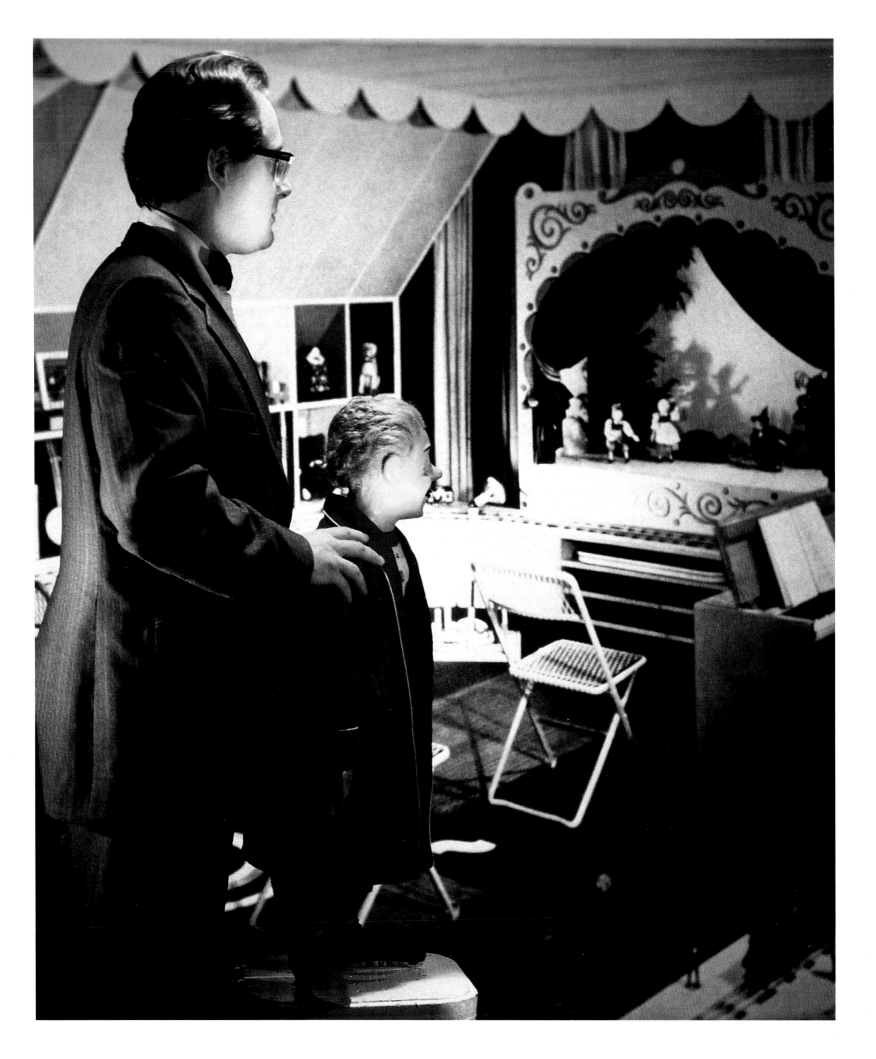

the "disembodiment" that Holmes had cited as a universal condition of modernity. Indeed, ventriloquism's "talking objects" are parallels to other "ghost phenomena" that emerged in the nineteenth century. As Connor observes, the "talking machine," or telephone, separated the voice from its source in space, while the phonograph divided them in time.[47] Perhaps the ultimate example of illusionary disembodiment developed in the twentieth century with the "talking picture," which Connor has cited for its "ventriloqual nature." But on another level, the dummy is an analogue for the author, similar but distinct, separated from him or her, much as "literature" is from "life." This kind of thrown or doubled voice animates the literary figure of the doppelganger, and it underlies the representation in literary theory of the relationship between author and text. And, once again, use of the dummy provided Simmons with a cover for "other" thoughts that might not be sanctioned under her own name or identity. In 1994 she reversed this position, taking on the role of the female figure in her series entitled The Music of Regret.

Simmons became interested in ventriloquism in 1986 when she was searching for a way to deal with male subjects and relationships. Clearly, childhood memories drew her toward what appeared to be a "fertile territory in terms of taking pictures. So many kinds of male relationships came up between vent and dummy: paternal, buddy love, best-friend love, brotherly love, homosexual love."[48] Again, Simmons's comments seem deceptively simple: some of her best work from this period involves male-female relationships, or relationships between viewers and objects of art. She contacted the ventriloquist Doug Skinner and began to photograph him and his dummy, Eddie Gray, against rear-projected images of domestic scenes (plates 26 and 40). In a group of two photogravures and a photolithograph dated 1986, the settings—mostly interiors and backgrounds taken from a trick photography book[49]— both suggest and stand in for the missing deceptions of the ventriloquist's voice. The photolithograph depicts the dummy alone, its flushed, leering face playing eerily on the difference between its illusional humanity and its status as an object.

In 1987 Simmons made the first of four trips to the Vent Haven Museum in Fort Mitchell, Kentucky, to photograph its historical collection of dummies, props, and photographic memorabilia. The resulting works from 1987–90 fall into three categories: portraits of figures, "talking objects" or props, and rephotographed publicity images of vent-and-dummy duos. The portraits present costumed dummies that Simmons selected, seated in chairs, and shot against rear-projected slides of lush colors, flowered wallpaper, or furniture-filled interiors. Despite the common view that ventriloquism presents a single face or physiognomy, the titles alone suggest the individuality of their subjects. *English Lady* (plate 35), *Pancho* (plate 36), *The Frenchman (Mickey)* (plate 23), and *June* (plate 27), to cite just a few, allude to the range of personalities that are "figured" on these lifeless dummies. Moreover,

26. *Doug and Eddy/ Puppet Show*, 1988
Cibachrome print,
24 x 20 in.
(61 x 50.8 cm)

Simmons depicted them in serious portraits based on art historical conventions. She derived her typical format—a half-length view showing hands and other "eloquent" features, and measuring some three by two feet—from discussions with the staff of the National Portrait Gallery in Washington, D.C. The spotlit plays of shadow and light, the skilled use of "body language," and the intricate coordination of figures, costumes, and backgrounds make for strikingly realistic representations. Simmons's photographs of dummies play on the lifelikeness or veracity that we attribute to portraiture, which customarily aims to present a "speaking likeness" of its subjects. The Talking Objects are portraits of common objects (a purse, a walking stick, and a handkerchief, among other things) that have been inscribed with expressive human features. Their anthropomorphism and the artist's use of shallow proscenium space look backward to the early years of ventriloquism and forward to the Walking and Lying Objects of 1987–91.

Simmons made four different *Vent Press Shots*, in each case arranging the twenty-five images in rows of five pictures so that the viewer can discern the differences and similarities in the relationships between figures and vents. One set, *Girl Vent Press Shots* (1988; plate 28), shows female vents posed with their usually, but not always, male figures. The women pose stagily—like showgirls—but Simmons has also remarked on similarities between those with boy figures and art historical representations of the Madonna and Child.[50] Two different *Boy Vent Press Shots* focus on subjects dressed in hats (1990; plate 39) and tuxedos. Simmons also made her own "girl vent press shot," pairing one of Skinner's boy figures with Skinner's girlfriend in the role of vent. Both vent and dummy turn toward the viewer, wearing similar expressions and clasping hands as if in complicity. Nevertheless, the superior role accorded to the "author" is evident in the vent's clear mastery of the situation.

In the figure portraits and the press shots, the animation of the dummies' features personalizes inanimate forms. Simmons's attention to their appearance is not unusual: many have commented on the demonstrativeness of the typical ventriloquist's dummy, whose clacking lips, wide-eyed expression, and swiveling gestures contrast with the restrained, often patrician features and behavior of the vent. Connor suggests that the features of the dummy give the voice a face, both fixing it temporally and providing an external and legible sign of otherwise invisible interiority.[51] In this view, which also is photographic, the externalization of speech in the dummy's features provides a sign of character and also expresses our inhering commitment to the "face" or "countenance" of things. Such signs are thus double and inherently duplicitous, at once profound and superficial, hinting at truth through surface appearances. If ventriloquism is a form of staged magic, then the dummy in Simmons's art is a crafted illusion, representing the external images of the self that we put out daily into the world.

27. *Jane*, 1988
Cibachrome print,
35 x 25 in.
(88.9 x 63.5 cm)

NEXT SPREAD:
28. *Girl Vent Press Shots, Part I*, 1988
Cibachrome print,
64 x 48 in.
(162.6 x 121.9 cm)
Girl Vent Press Shots, Part II, 1988
25 Cibachrome prints, 8 x 10 in.
(20.3 x 25.4 cm), each

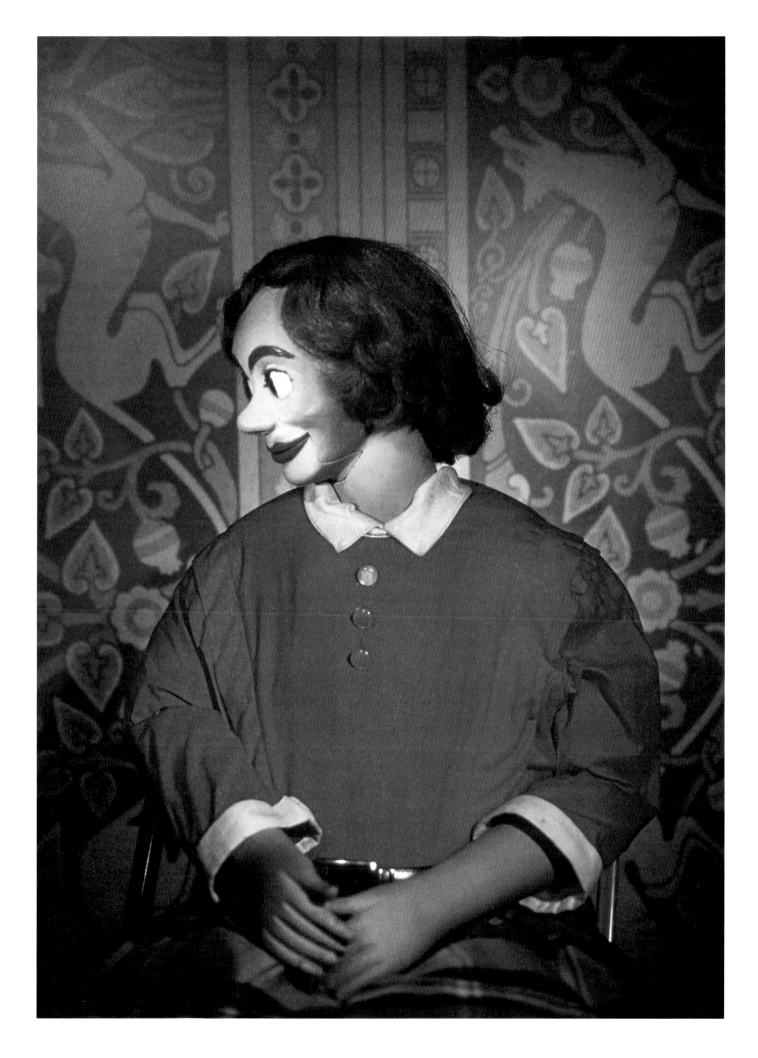

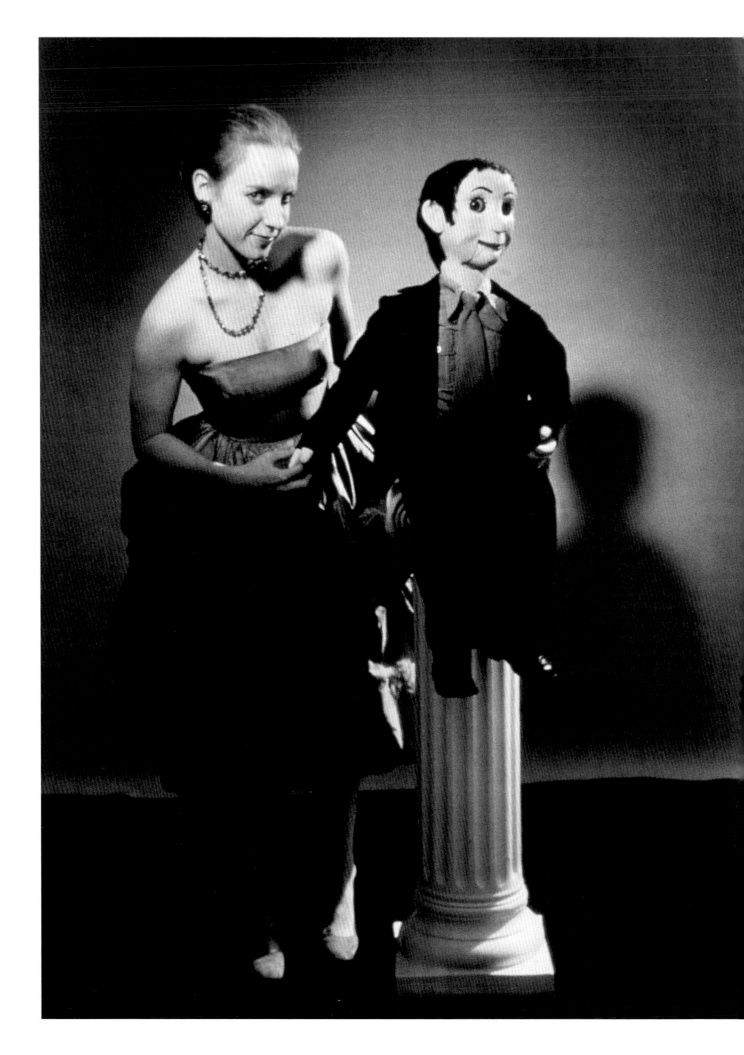

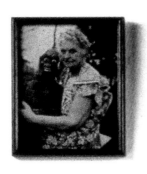 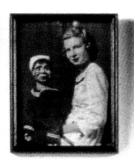 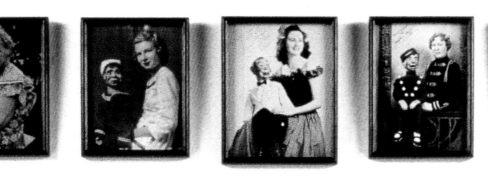 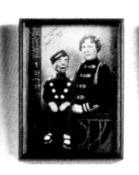 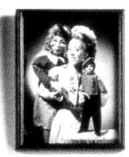

 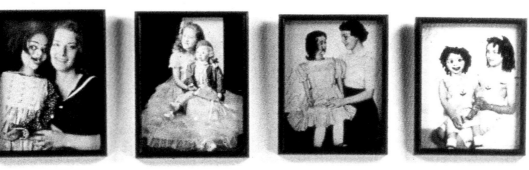 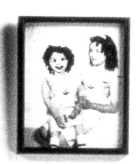

 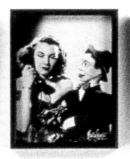

 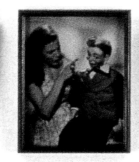 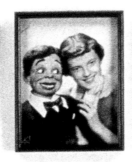 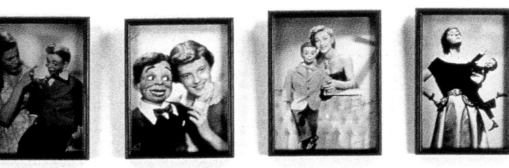 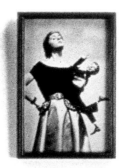

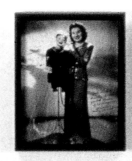 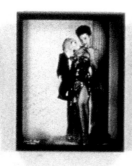 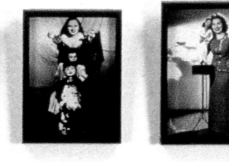 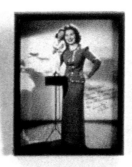

By 1988 Simmons had moved away from ventriloquism, abandoning its noisy, wisecracking, largely misogynistic world for the silence and austerity of the Walking and Lying Objects. Still, the dummy-figure recurs, starting in 1990, as a device that permits the artist to address a range of themes, among them the doubled voice of the author, the equivocation between human and inhuman, and the self's externalizing representations. Simmons began working on her own male dummy face with the vent and figure maker Alan Semok in 1989. Characteristically, the resulting dummy conforms to her memory rather than to "real" experience; its "smart-alecky 1950s–1960s look," in the artist's words, offers "a compilation of my recollection of what a dummy is supposed to look like."[52] This dummy appears in three series: Clothes Make the Man (1990–92), Café of the Inner Mind (1994), and The Music of Regret (1994). It is not incorrect to assume that Simmons also appears invisibly in these works, as the unseen vent or author who throws her voice or critical commentary through the figure. As she employs the dummy with renewed assurance and skill, the result is a deepening of the critical and reflective quality of Simmons's work.

In Clothes Make the Man the dummy looks as if it has been cloned, resulting in multiple identical figures with the same features. Made out of molded fiberglass, the figures are technically sculptures, allowing Simmons to reexamine the tactile and object qualities that she had appreciated earlier in the Vent Haven dummies. She first exhibited the dummies in 1992 in an installation in which she mounted them on chairs evenly spaced against a neutral gallery wall (plates 69 and 76). They appeared isolated, distinguished only by dress. In this context, external variations in ties, shoes, or the fabric and cut of jackets create a world of meaning, differentiating the figures from one another and giving them distinct personalities. On one level, Clothes Make the Man plays with the ventriloqual theme of visible signs of invisible interiority. The hackneyed phrases of the subtitles ("don't ask," "you betcha," "ask any woman," and so on) put words into the dummies' mouths, echoing verbal exchanges with the vents. However, the major theme of the series is conformity, or social uniformity, in which difference can be located only in the inconsequential minutia of dress. Simmons's title provides a satirical commentary on the common notion of self-expression through clothing. As a series, Clothes Make the Man is a partner to the monochrome Interiors from 1982–83. Much as the women in the earlier series appeared to fade into their environments, here only minute variations in external features make the men stand out from one another. Their external trappings—Harris tweed coats, silky tuxedos, coordinated shirts and ties—are analogues to the decorative features of the women's basically identical rooms. Clothes Make the Man is a bittersweet evocation of a human world that is known through its surfaces, its images, through how it looks.

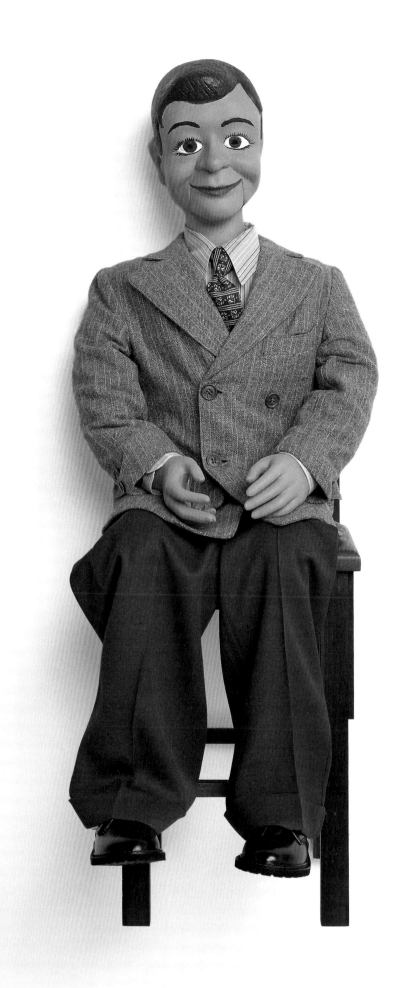

29. *Clothes Make the Man*
(always did, always will), 1992
Fiberglass, wood, nylon, clothing,
39 x 12 x 15 in.
(99.1 x 30.5 x 38.1 cm)

In 1994 Simmons began to focus on the inner thoughts or imaginings of her dummy-figures. The title of the series, Café of the Inner Mind, calls up an interior space of chatter and musing as well as a paradigmatically public place of modern social relationships. The works signal a return to some of the settings of her late 1970s interiors, now abstracted or transformed. For example, the pristine bathrooms of the earlier works recur in the masculine version of public toilets or "men's rooms." Inside them, the dummies appear as if character-types—"typical men"—engaged in the characteristic pastime of thinking dirty thoughts about women. Cartoon bubbles, collaged in with a computer, contain visual equivalents of their fantasies, which are unsurprisingly conventional—tits-and-ass views of women as sex objects, lifted out of pornographic magazines. In *Men's Room* (plate 80), Simmons critically transforms ventriloquism's inherent misogyny, using it against itself to make jokes at the expense of men. Elsewhere, the dummies appear together in a bourgeois dining room (*Gold Café*, plate 79) or solo, lounging in a flower-filled field against a cerulean blue sky (*Caroline's Field*, plate 84). The field represents a romaticized space of longing and desire—variations occur in Andrew Wyeth's *Christina's World* as well as *The Wizard of Oz*—but also the site of the dummy's more pedestrian fantasies about a sexual trio.

In 1994 Simmons also began to address her own self-representation, modeling a figure after herself. Dark-haired, pale-skinned, and made with uncharacteristic movable eyes, the dummy is at once a surrogate for and an image of the artist. As a surrogate, the dummy is the culmination of the ventriloqual works, collapsing the duality of vent and figure into a single, eloquent form. Simmons's figure appears with her male dummies in a series of photographs titled The Music of Regret; a related mannequin is deployed in *The Umbrellas of Cherbourg* (1996; plate 96) and also in the Black Bathroom works from 1997 (plates 31, 89–91). At the time Simmons was looking for a way to deal with male-female relationships, and the use of her own image, as Howard has remarked, "eliminated making decisions about what her female dummy should look like."[53] Additionally, the choice of her own image allowed her to fold her experience into the theme of regret, which is a melancholic acknowledgment of the past's immanence in the present. Simmons has also explained this self-portraiture simply and profoundly: after having fantasized as a child about being the muse of a great artist, she decided to become her own muse.[54] For a woman artist to take herself as a source of inspiration, using her own experience as the substance of her art, counters historical representations of women and, in particular, their representation in Surrealism, which portrayed women and muses as objects of male delectation. It is in the role of her muse that Simmons appears in *The Music of Regret IV* and *XIII* (plates 30 and 88), centrally

30. *The Music of Regret IV (Color)*, 1994
Cibachrome print, 19½ x 19½ in. (49.5 x 49.5 cm)

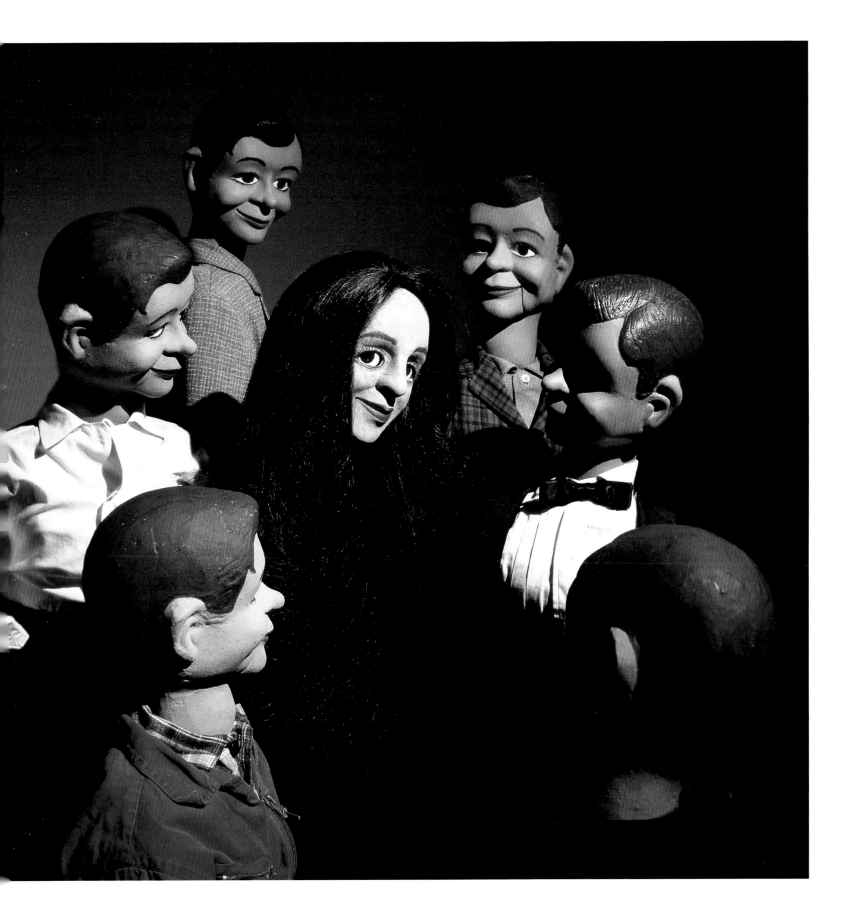

placed and surrounded by her masculine creations. The format consciously or unconsciously repeats the format of certain Surrealist paintings and group portraits that depict women as an absent or invisible center, but with one difference: Simmons has replaced woman's image as the object of desire with the figure of the desiring and inspiring subject.

The implications of Simmons's "self-figuring" are also philosophical and photographic. Using the vehicle of self-portraiture, Simmons has addressed the camera's characteristic objectification of its subjects. For example, all of us know the profound equivocation between subject and object, or human and inhuman states, that occurs in the process of self-reflection. The visual analogue of such reflexive speculation occurs only in those rare instances—mirrors and photographs—in which the self is re-presented as an image. As Roland Barthes has formulated the paradox: "You are the only one who can never see yourself except as an image."[55] This process by which the subject "sees itself" is at once objectifying and imaginal; the human body is both transformed ontologically from a subject into an object and transposed visually onto the surface of a plane. The result of this reification of the self in photography is that the subject is dis-embodied. (Barthes also suggests that in being photographed, "I instantaneously make another body for myself, I transform myself in advance into an image"[56] by *posing* for the camera.) The adjectives that philosophers have applied to photographs—*ghostly*, *spectral*, and *melancholy*, among them—all suggest both the disembodiment of the image and its distance from its origin or source. The "spectral" quality of the mirror image also derives from its distance from its source as an imaginary object projected onto a plane rather than a "real" subject. However, ventriloquism not only maintains the distance of the disembodied voice, but also projects it onto the pre-objectified, superficial form of the dummy. These distinctions inhere in Simmons's choice of representation: by portraying herself in the figure of a ventriloquist's dummy, Simmons has made a picture of picturing that configures the inevitable distance in self-representation.

The eroticism of distance is the subject of Simmons's multimedia installation *The Umbrellas of Cherbourg*, in which the artist used her own image in an allusive, indirect reading of the sexual, spatial, and photographic play of Marcel Duchamp's final artwork, *Etant Données* (1946–66). The direct source for Simmons's work is the 1964 musical film *The Umbrellas of Cherbourg*, and her use of a mannequin styled after herself allowed her to replay a teenage fantasy of being the star of the film, Catherine Deneuve. Howard has correctly noted that Simmons constructed the work as a site for female rather than male fantasy.[57] She constructed a peephole viewing point, as in Duchamp's work, and placed her seated image at a distance inside, wearing a raincoat, holding an umbrella, and drenched in rain. The work reiterates the artist's key themes and elements: role-playing, shallow "performance" space, longing,

31. *Black Bathroom (View through Window/ March 26, 1997)*, 1997 Cibachrome print, 40 x 28 in. (101.6 x 71.1 cm)

melancholy, the solitary and isolated woman. Yet, as in Duchamp's work, the peephole structure both positions the observer as a viewer/voyeur and entails a play on the architecture and spatial dynamics of the camera, which transforms its corporeal subjects into disembodied images. And, significantly, Simmons has rewritten, or reimagined, Duchamp's use of the figure of the mannequin. Whereas Duchamp constructed a mannequin using the body of his mistress, Maria Martins, and placed her lying naked in the foreground of his work, Simmons has responded with her own clothed, upright, and secretive figure. Her tactic thus replaces the object of desire with the desiring and inspiring subject. This self-figuring recurs in the Black Bathrooms, in which Simmons makes use of the same mannequin as well as the viewer/voyeur. Here, she has retrieved the bathroom interiors from her past, subjecting them to the elaborating power of memory and replacing the lonely housewife with herself lying in the bathtub in the role of a moody noir heroine. Everything—from the skewed angles, foreshortened perspective, and pristine objects to the flickering light—echoes a past that the artist has revisited and recast in newly erotic terms. Time appears distended; surfaces provide a scintillating visual field; and the light through a small window briefly interrupts the pattern of shadows projected on the tiled floor. In one work, *Black Bathroom (View through Window, March 26, 1997)* (plate 31), the peephole/viewfinder/window provides a view onto the past as if glimpsed at a specific time and place. Everything is set at a distance. The mullioned window, much like the lenses of Proust's memory, suggests an always occulted space: 11 Strathmore Road.

In Simmons's recent series Long House (2002–4; plate 13), the figure- and object-lessons of the works from 1987–97 have been incorporated and reinterpreted. All are variations on the theme of a domestic interior furnished with objects and inhabited by a solitary female figure, captured in thought. However, the light that enters the interiors through different apertures turns the spaces into a kaleidoscope of colored frames—surfaces whose exact dimensions are confused further by inner plays of reverberating reflections. The overall effect is intense, subjective, irrational—or, as Benjamin would say, "surrealist." Simmons has composed these works as narratives of female imaginings, throwing or projecting her voice onto the images around the figure. The surfaces of objects have been taken over or appropriated by the human subject and now appear as stimuli or receptacles for thought. In this process, the photographic surface has been redefined as a skin that is sufficiently plastic, and elastic, to encompass the artist's reflections as they echo and ricochet off silent images and objects. The result both registers the subjective meanderings of thought and represents the artist's mission: to configure her own interiority, using photography's inherent but little-acknowledged capacity to lie, deceive, and falsify in the pursuit of larger truths.

NOTES

1. Jan Howard, "Picturing Memories," in *Laurie Simmons: The Music of Regret* (Baltimore: Baltimore Museum of Art, 1997), p. 17. Howard's excellent text remains the most authoritative source to date on Simmons's art, and I am indebted to it for many facts and points of interpretation about the artist's work.

2. Carol Squiers, "The Mnemonic Image," in *Laurie Simmons: In and Around the House, Photographs 1976–78* (New York: Carolina Nitsch Editions, 2003), p. 11.

3. Simmons, interviewed by Sarah Charlesworth, in *Laurie Simmons* (New York: A.R.T. Press, 1994), p. 9.

4. Thomas Hine, *Populuxe* (New York: Alfred A. Knopf, 1986), p. 10.

5. Ibid., p. 65.

6. Victoria de Grazia, "Establishing the Modern Consumer Household," in de Grazia with Ellen Furlough, eds., *The Sex of Things: Gender and Consumption in Historical Perspective* (Berkeley and Los Angeles: University of California Press, 1996), p. 157.

7. Howard, *Music of Regret*, p. 20.

8. Hine, *Populuxe*, p. 70.

9. Lynne Tillman, *Haunted Houses* (New York: Poseidon Press, 1987), p. 21.

10. Howard, *Music of Regret*, p. 23.

11. Stuart Ewen, *All-Consuming Images: The Politics of Style in Contemporary Culture* (New York: Basic Books, 1987), p. 70. Ewen's analysis of the implications of style and design in American life is remarkable, and perceptive readers will find echoes of his insights throughout my treatment of postwar suburban culture.

12. Ibid., pp. 68–71.

13. Joan Kron, *Home-Psych: The Social Psychology of Home and Decoration*, p. 263, in Ewen, p. 70.

14. Ewen, *All-Consuming Images*, passim.

15. Oliver Wendell Holmes, ibid., p. 25. It is a tribute to the importance that Ewen finds in Holmes's reading of photography for an overall understanding of the way style operates in the modern world that he places his discussion of it near the beginning of his book in a chapter titled "Goods and Surfaces." See pp. 24–26.

16. Holmes, ibid., p. 25.

17. See Ewen, ibid., pp. 34–36 and 227–32.

18. Hine, *Populuxe*, p. 81. Ewen also draws on Hine for his discussion of the "new materials" of postwar decorating.

19. Ewen, *All-Consuming Images*, pp. 226–32. Ewen is excellent on the notion of the variety afforded by the use of a single floor plan in the standard developer's scheme. See also Hine, *Populuxe*, pp. 37–58.

20. Ewen, *All-Consuming Images*, p. 232.

21. Ibid., pp. 106–8, 176–80. Ewen includes Loewy, among others, in his excellent discussion of anthropomorphism. His discussion of the aggressive "marketing strategies" that worked in tandem with twentieth-century "style industries" refers to the influence of J. Gordon Lippincott's notion of "products that have a personality."

22. Hine, *Populuxe*, p. 64.

23. Ewen, *All-Consuming Images* , p.107.

24. A. M. Homes, *The Safety of Objects* (New York: Rob Weisbach Books, 1990), p. 129.

25. De Grazia, "Introduction," in de Grazia with Ellen Furlough, eds., *The Sex of Things*, p. 1.

26. Simmons, interview by Charlesworth, p. 9.

27. In conversation Simmons has referred to period codes and conventions of fashion: patent-leather pumps for special occasions, matte for everyday; white for summer but never in the winter, and so on. Conversation with the author, November 14, 2004.

28. Howard, passim and conversations with the author. Simmons has observed that the theatrical quality of her own world was common to 1950s suburban experience. Any child of the period remembers the "special" feeling of events, whether class trips, school plays, holiday pageants, or skating lessons in which girls wore fluffy hats, mittens, and circular skating skirts trimmed in white fake fur. The sense of staged representation extended to the minute particulars of daily existence.

29. Simmons, "In and Around the House: Text by Laurie Simmons," in *In and Around the House*, pp. 20–21.

30. See, for example, the discussion of other artists working with tableaux in Paula Marincola, "Stock Situations/ Reasonable Facsimiles," in *Image Scavengers: Photography* (Philadelphia: Institute of Contemporary Art, 1982), pp. 5–26.

31. Simmons, *In and Around the House*, pp. 15–16.

32. Ibid., p. 20.

33. All quotations are from Walter Benjamin, "The Image of Proust," in Hannah Arendt, ed., *Illuminations* (New York: Schocken, 1973), pp. 201–15.

34. Perhaps the most astute analyst of Proust's vision is Roger Shattuck. See Shattuck, *Proust's Binoculars: A Study of Memory, Time and Recognition in "À la Recherche du Temps Perdu"* (New York: Random House, 1963).

35. Barbara Kruger, *Remote Control* (Cambridge and London: MIT Press, 1993), pp. 86–89.

36. For information on commercials and television advertising, see Lawrence R. Samuel, *Brought to You By: Postwar Television Advertising and the American Dream* (Austin: University of Texas Press, 2001).

37. Simmons, in *After Modernism: The Dilemma of Influence*, Michael Blackwood Productions, Inc., 1992, videocassette; from Howard, *Music of Regret*, p. 56.

38. Conversation with the author, November 14, 2005. Perhaps unconsciously, Simmons's nouns echo the names of two of the dwarfs in an early 1950s commercial for Chevrolet.

39. Whitney Chadwick, *Women Artists and the Surrealist Movement* (Boston: Little, Brown, 1985), p. 118.

40. Simmons, interview by Charlesworth, p. 20.

41. Ibid., p. 28.

42. Howard, *Music of Regret*, p. 59.

43. Simmons, interview by Charlesworth, p. 26.

44. Steven Connor, *Dumbstruck: A Cultural History of Ventriloquism* (New York: Oxford University Press, 2000), p. 249.

45. Ibid., p. 398.

46. Ibid., p. 399.

47. Ibid., p. 364.

48. Simmons, interviewed by Linda Yablonsky, *Bomb* 57 (Fall 1996), p. 19.

49. Howard, *Music of Regret*, p. 50.

50. Ibid., p. 55.

51. Connor, *Dumbstruck*, p. 401.

52. Howard, *Music of Regret*, p. 61.

53. Ibid., p. 65.

54. Ibid.

55. Barthes, in *Roland Barthes*, cited in Martin Jay, *Downcast Eyes: The Denigration of Vision in Twentieth-Century French Thought* (Berkeley and Los Angeles: University of California Press, 1993), p. 448.

56. Roland Barthes, *Camera Lucida: Reflections on Photography*, trans. Richard Howard (New York: Hill and Wang, 1981), p. 10.

57. Howard, *Music of Regret*, p. 67.

My Trip to Vent Haven

In 1986 I wanted to change the way I worked. Actually, I wanted to start over. I can't truly say that I wanted to disown all my pictures from 1976 to 1985, but I did have a strong desire to be a different artist. Basically, I was tired of shooting images of women, which, with the exception of some plastic cowboys and a plastic frogman, I'd done nonstop for almost ten years.

How could I photograph men in my language? I mulled over the possibilities of plastic TV characters and G.I. Joes and Ken dolls. How to get the visual essence of "guy"? I thought about all the representations of men that might operate in the same way as a doll. Archaic cultures are crawling with totemic figures, from Kachinas to those legions of ceramic soldiers that guard the tombs of Chinese emperors. More recent history provides toy soldiers and superheroes. I kept returning to the image of an early, almost pre-memory Christmas present given to my older sister. It was a ventriloquist doll in a green suit with brown trim. I feel as though we spent the better part of our childhood trying to talk without moving our lips. My sisters and I often drew mouths and eyes on our closed fists in imitation of Señor Wences, a ventriloquist who threw his voice on TV shows, using few props and little dialogue.

Conceptually, I loved the notion of ventriloquism. Men speaking through surrogate selves and not having to take responsibility for their thoughts or actions. I remembered "The dummy did it" or "the dummy made me do it" as the operating principle of most of the skits I saw on TV or at birthday parties. Visually, I was rather indifferent. I didn't love the way dummies (or ventriloquists) looked—too spooky, too homemade, too much caricature, and way too many bad jokes. But a more photojournalistic urge revealed itself to me, and I set off to find out what I could about ventriloquism. I was definitely drawn to the sad and tender notion of a marginal form of entertainment. Ventriloquism was its own kind of disappearing act. Where were all the ventriloquists and dummies? From what I could figure out, they were mostly getting jobs on cruise ships, at state fairs, and for church functions. The first ventriloquist I met in New York was a man called Doug Skinner, whose dummy was named Eddie Gray. Skinner had worked with the performance artist and clown Bill Irwin, and he was a great resource and something of a historian. He lent me books and records and eventually directed me to Vent Haven, a kind of ad hoc museum in Fort Mitchell, Kentucky. Vent Haven was founded in the suburban home of a retired businessman with a passion for ventriloquism, who had done some amateur performing on his own. There is absolutely no other place like this in the United States, so Vent Haven has become the repository for any and all ventriloqual material worth donating (as well as a site for study, with its own curator). Once a year the museum hosts a convention, a national gathering for ventriloquists to meet and greet, entertain and study, complete with its own parade.

I made several trips to the museum, which turned out to be a short walk through the hedges in back of the Holiday Inn where I always stayed. The museum was made up of several prefab outbuildings in the backyard of a nondescript suburban house. The structures were set up like classrooms, with several dozen child-size folding metal chairs, each containing a fully clothed dummy. The rooms had an odd rec-room feel, with wood paneling and sound-deadening ceiling tile, as though the kids might act up at night.

The walls were covered with ventriloquists' press shots and memorabilia sent from all over the world. I had to make a $150 donation each time I came to work.

Every day my assistant and I would walk over to the museum and set up a small rear-screen projection system, tiny theater lights, and one chair. Only I was granted permission to pick up the figures, so I spent most of the day carrying dummies back and forth from their chairs to my set-up. The most difficult part was choosing which dummies to photograph. At the time I was interested in Irving Penn's ethnographic studies and images of anonymous people photographed within the contrived setting of a makeshift studio. Since the Vent Haven figures represented many races, nationalities, and animals, I felt like I was engaged in a cultural study—the biggest surprise being how many girl dummies and female ventriloquist press shots I encountered. In my makeshift studio I projected background images of rooms and landscapes to give the dummies a sense of place outside the museum.

On my first trips, I photographed dummies of all types. During subsequent visits, I found talking objects like handkerchiefs, beer steins, and walking sticks, which I placed in front of examples of my rapidly expanding collection of slide backgrounds. In 1984 I'd started amassing notebooks full of slides organized by type, like wallpaper patterns, interiors, scenes from nature, etc. On my last trip, I photographed the press shots as they appeared on the walls. I shot with color film even though the press shots were all black-and-white prints. They had faded over time to beautiful duotones of sepia, blue, pink, and purple.

My vent archives were getting full. I subscribed to several rinky-dink ventriloquist newsletters and prop catalogs. Friends were sending me "how to" books as well as recordings of vent dialogue and music by pros like Paul Winchell and Shari Lewis. I collected articles and artifacts. My files and knowledge were growing as my interest was waning. After I made the *Girl Vent Press Shots* (twenty-five press pictures of female ventriloquists; plate 28) and the *Boy Vent Press Shots* (groups of ventriloquist press shots organized by themes like "hats" [plate 39], "tuxedos," and "animal characters"), the series was over.

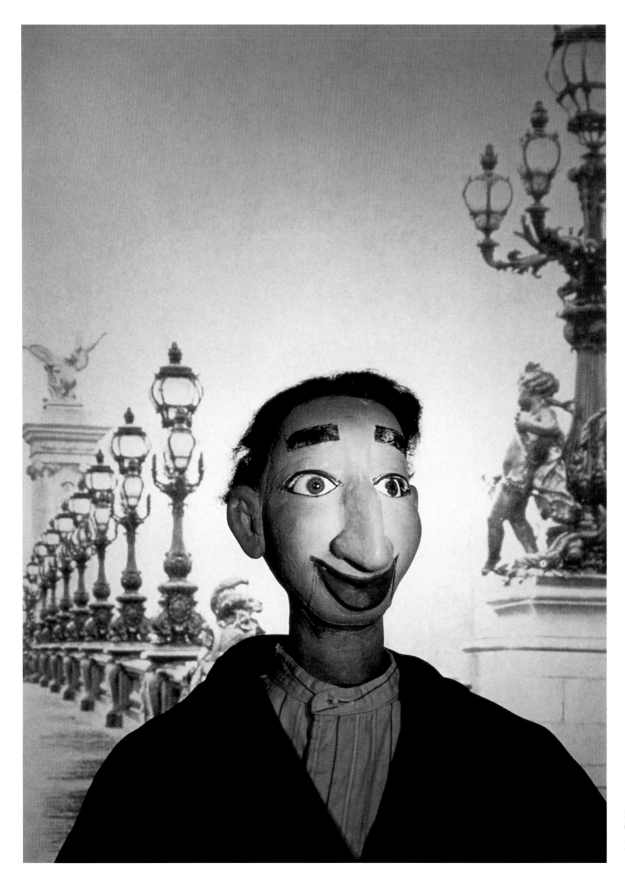

32. *Izzy*, 1988
Cibachrome print,
35 x 25 in.
(88.9 x 63.5 cm)

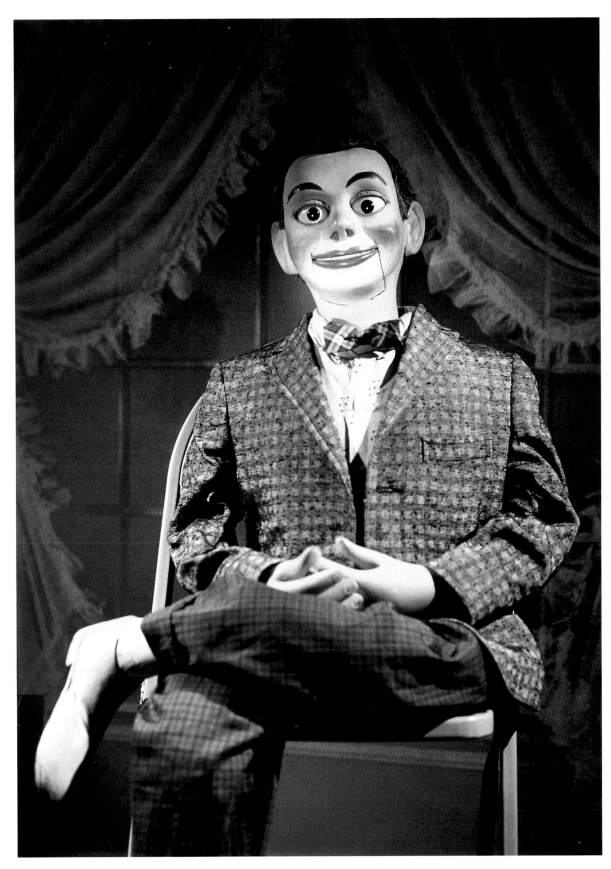

33. *Young Man
(Unnamed)*, 1987
Cibachrome print,
35 x 25 in.
(88.9 x 63.5 cm)

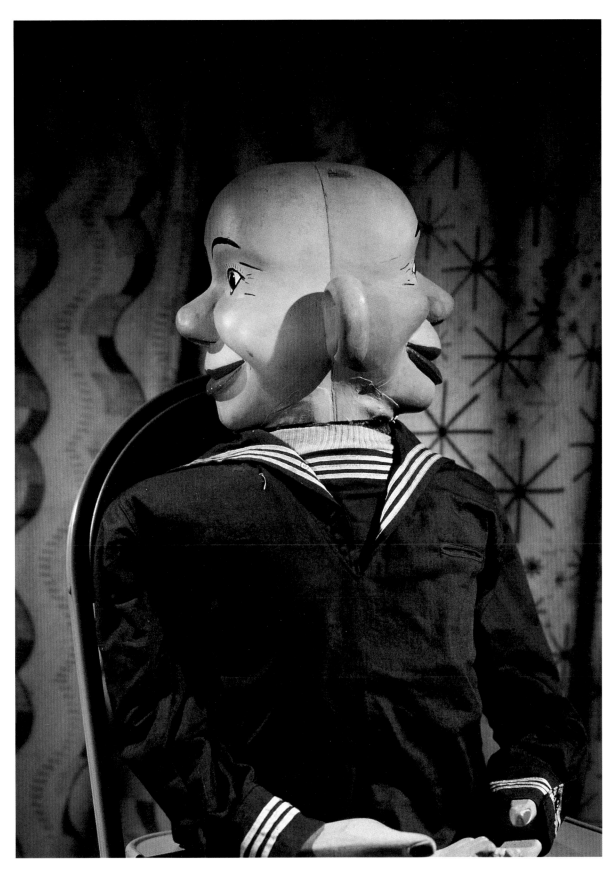

34. *Two-Faced Figure*, 1987
Cibachrome print,
35 x 25 in.
(88.9 x 63.5 cm)

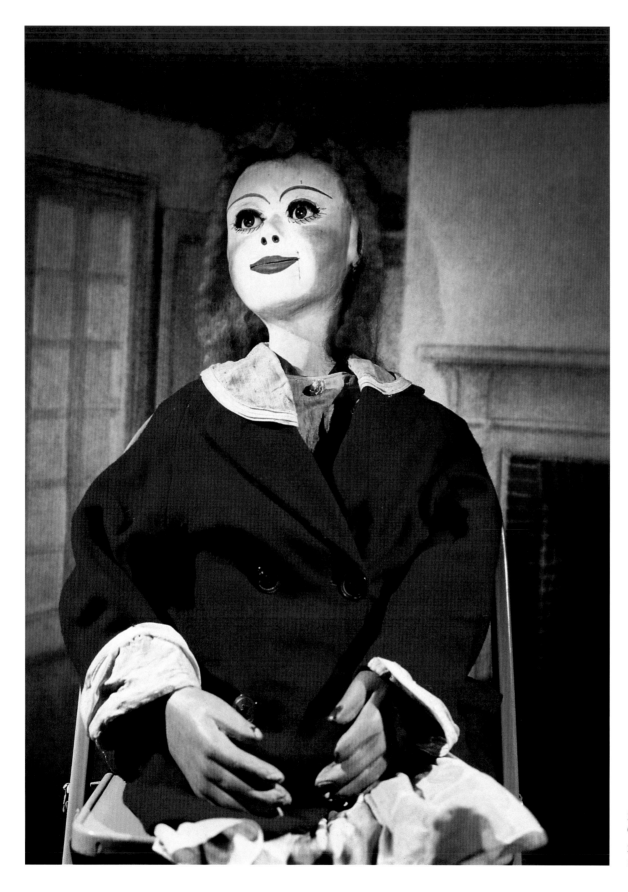

35. *English Lady*, 1987
Cibachrome print,
35 x 25 in.
(88.9 x 63.5 cm)

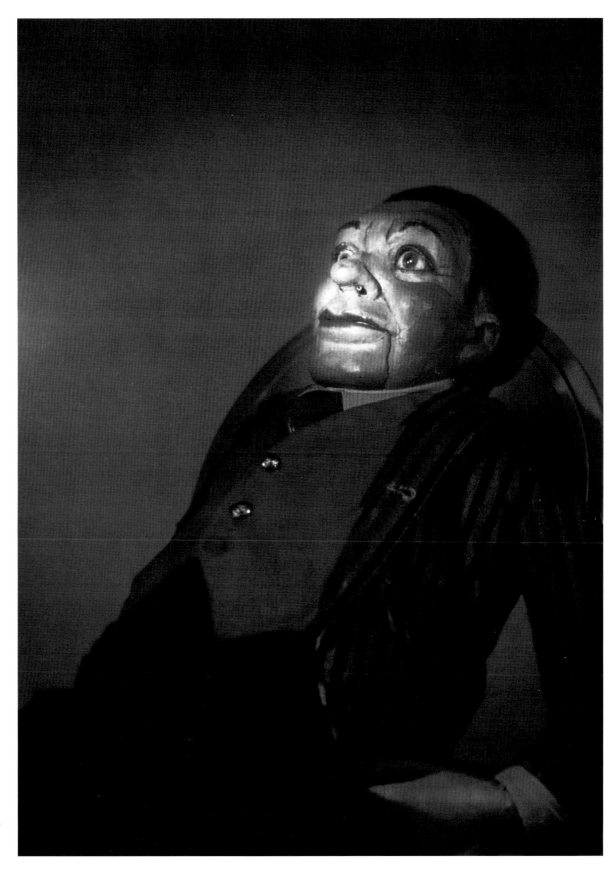

36. *Pancho*, 1988
Cibachrome print,
35 x 25 in.
(88.9 x 63.5 cm)

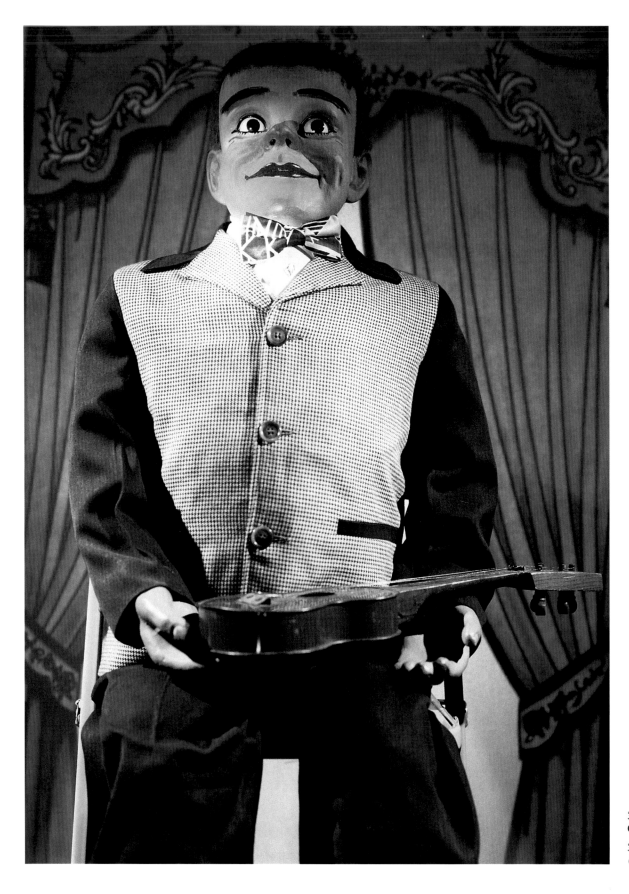

37. *Ukulele Player,* 1987
Cibachrome print,
35 x 25 in.
(88.9 x 63.5 cm)

38. *Suzie Swine*, 1987
Cibachrome print,
35 x 25 in.
(88.9 x 63.5 cm)

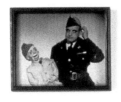 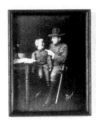 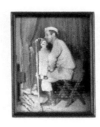 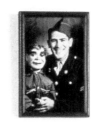 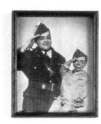

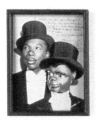 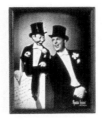 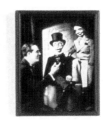

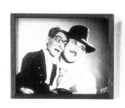

 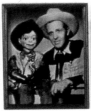 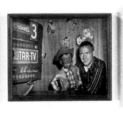 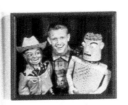

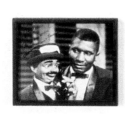 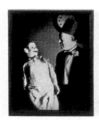 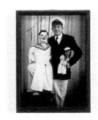 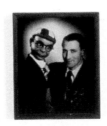 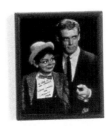

LEFT:

39. *Boy Vent Press Shots (Hats)*, 1990
25 Cibachrome prints,
8 x 10 in.
(20.3 x 25.4 cm), each

OPPOSITE:

40. *Doug and Eddy/Eddy Floating/Den*, 1987
Cibachrome print,
24 x 24 in.
(61 x 61 cm)

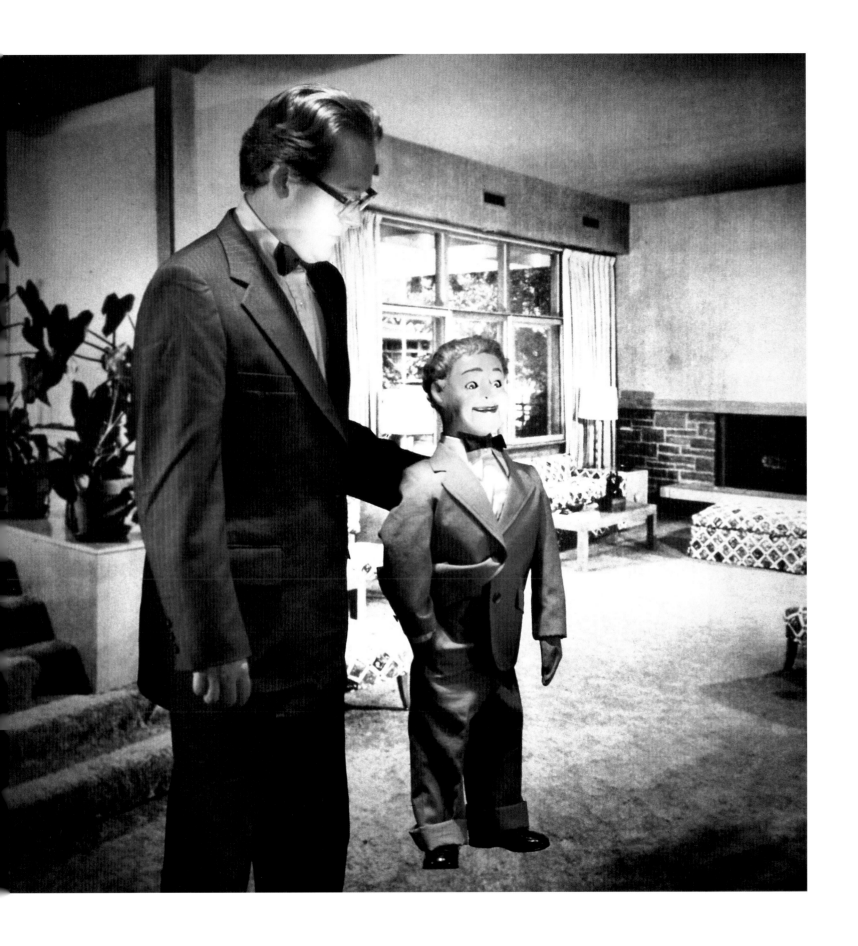

41. *Talking Purse,* 1987
Cibachrome print,
64 x 48 in.
(162.6 x 121.9 cm)

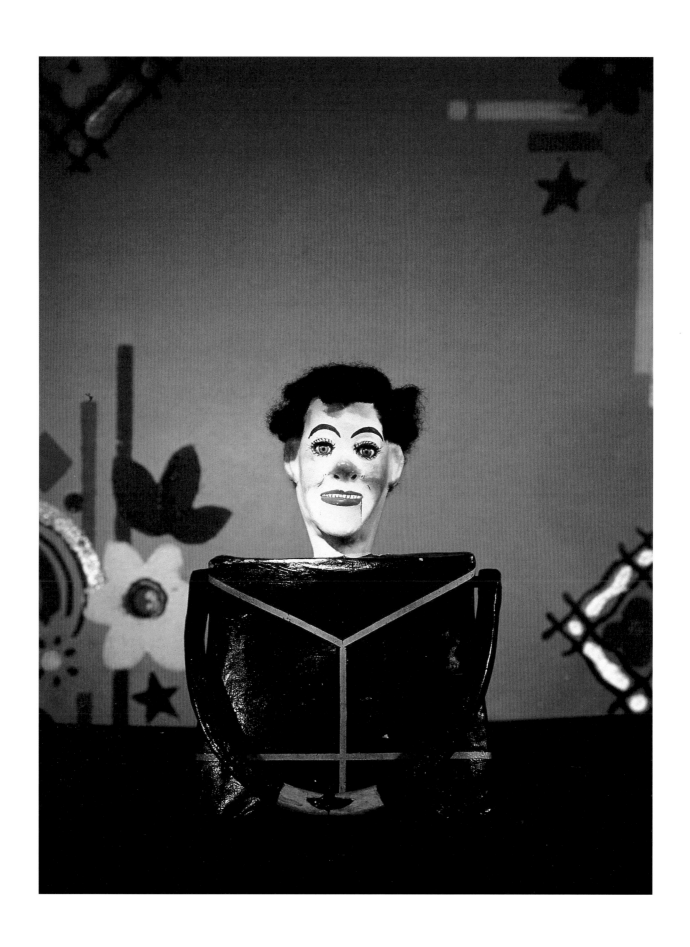

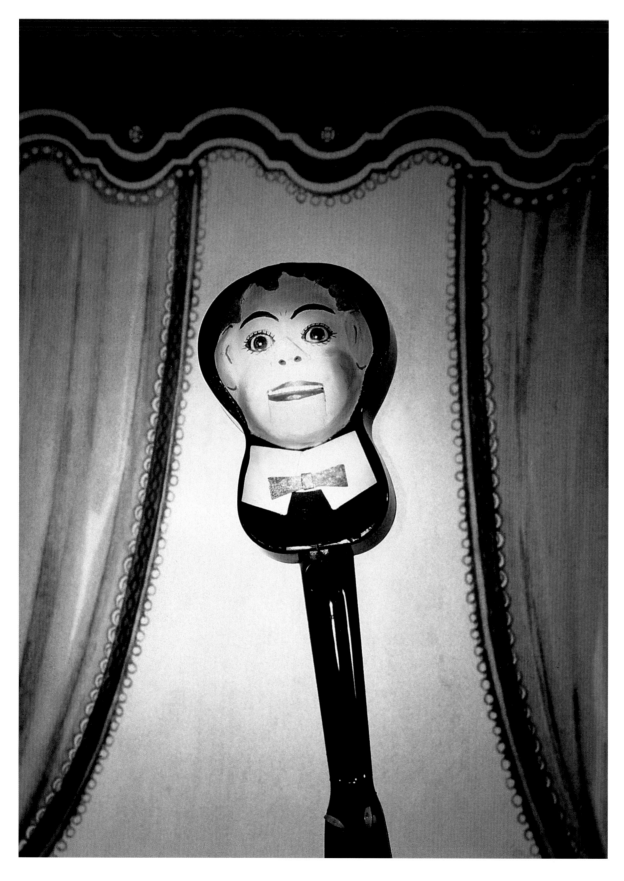

42. *Talking Ukulele*, 1987
Cibachrome print,
64 x 46 in.
(162.6 x 116.8 cm)

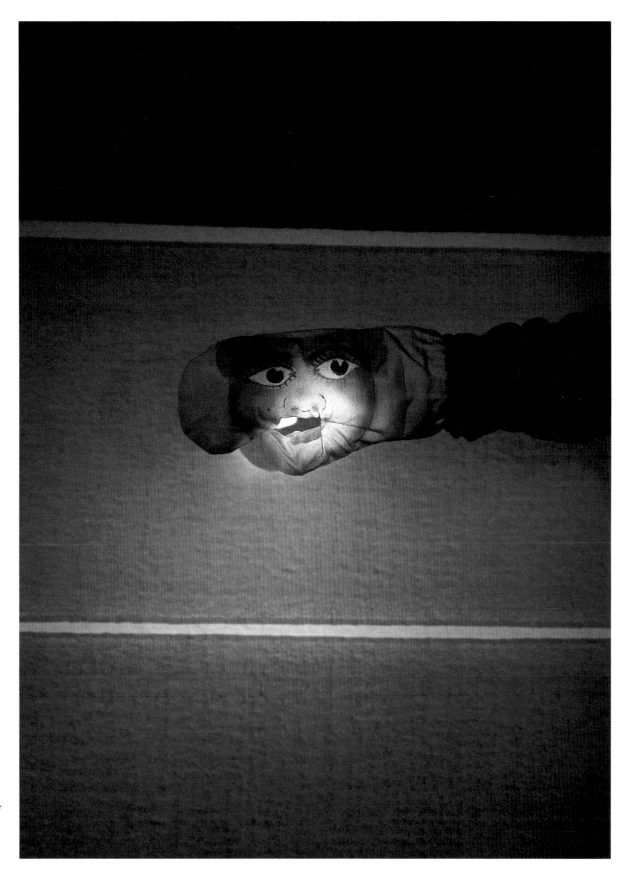

43. *Talking Mitt*, 1987
Cibachrome print,
64 x 46 in.
(162.6 x 116.8 cm)

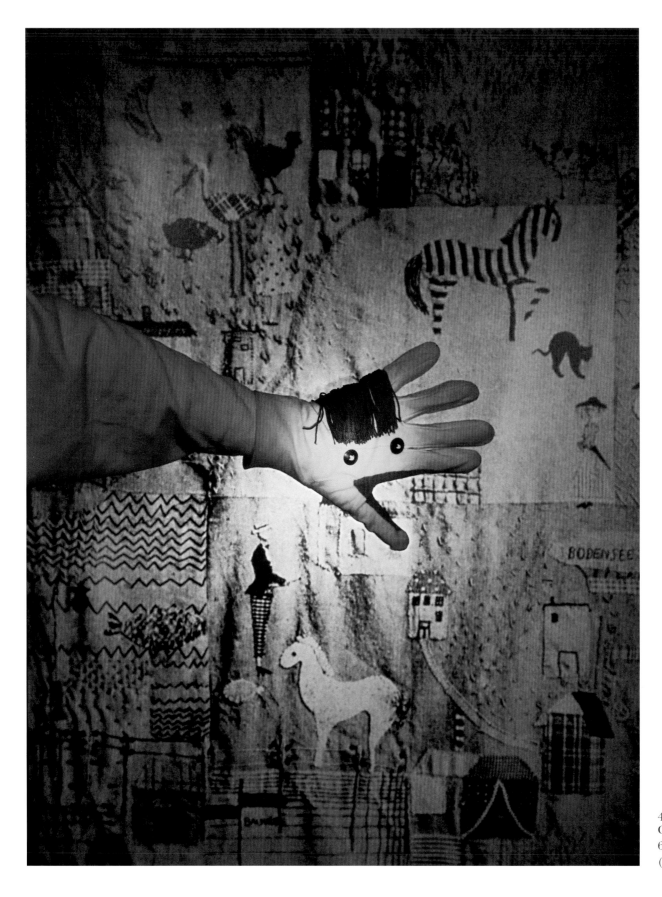

44. *Talking Glove*, 1988
Cibachrome print,
64 x 48 in.
(162.6 x 121.9 cm)

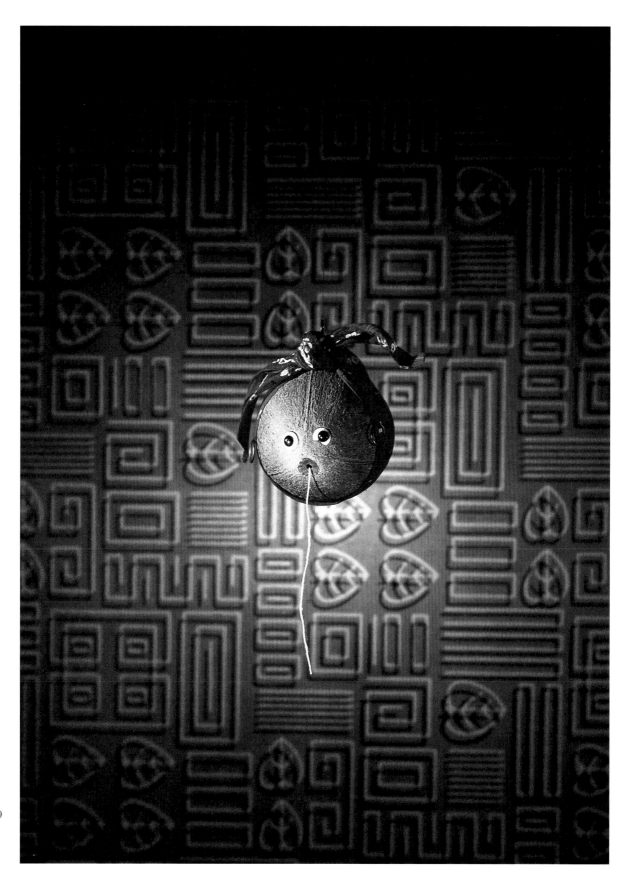

45. *Talking Coconut (String Dispenser)*, 1989
Cibachrome print,
64 x 46 in.
(162.6 x 116.8 cm)

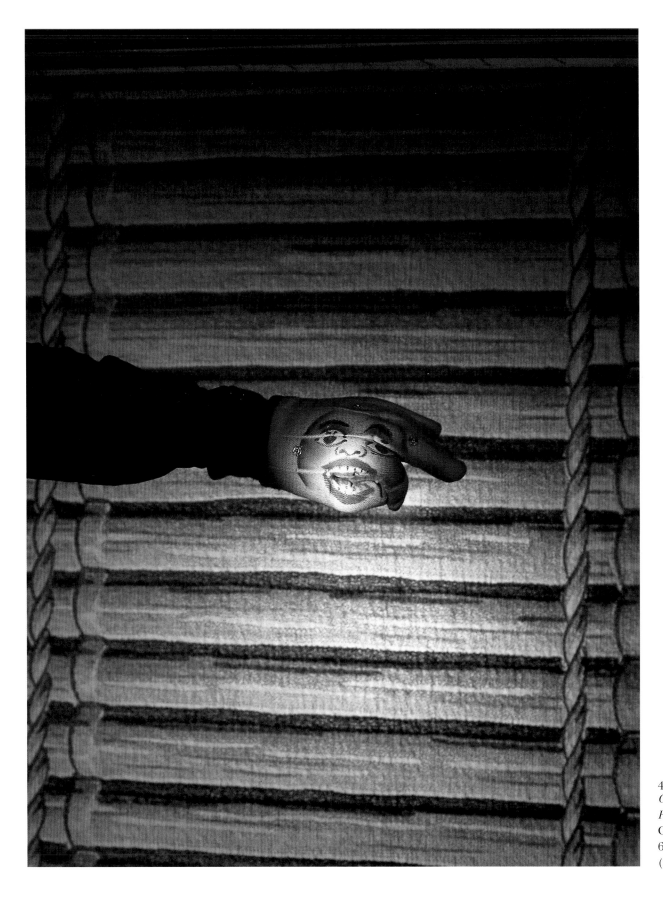

46. *Talking Gardening Glove (Madame Pinxy's)*, 1987
Cibachrome print,
64 x 48 in.
(162.6 x 121.9 cm)

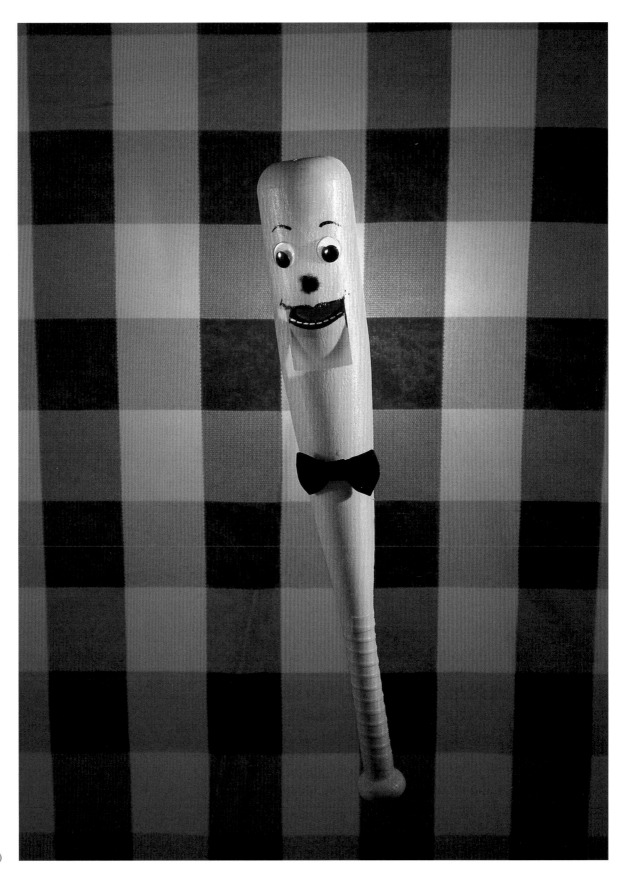

47. *Talking
Baseball Bat,* 1989
Cibachrome print,
64 x 46 in.
(162.6 x 116.8 cm)

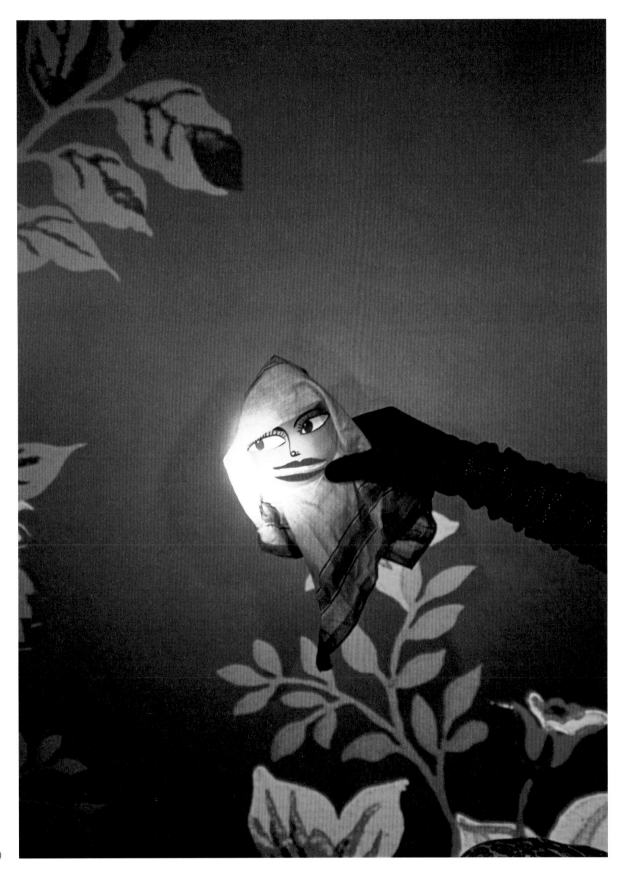

48. *Talking Handkerchief,* 1987
Cibachrome print,
64 x 46 in.
(162.6 x 116.8 cm)

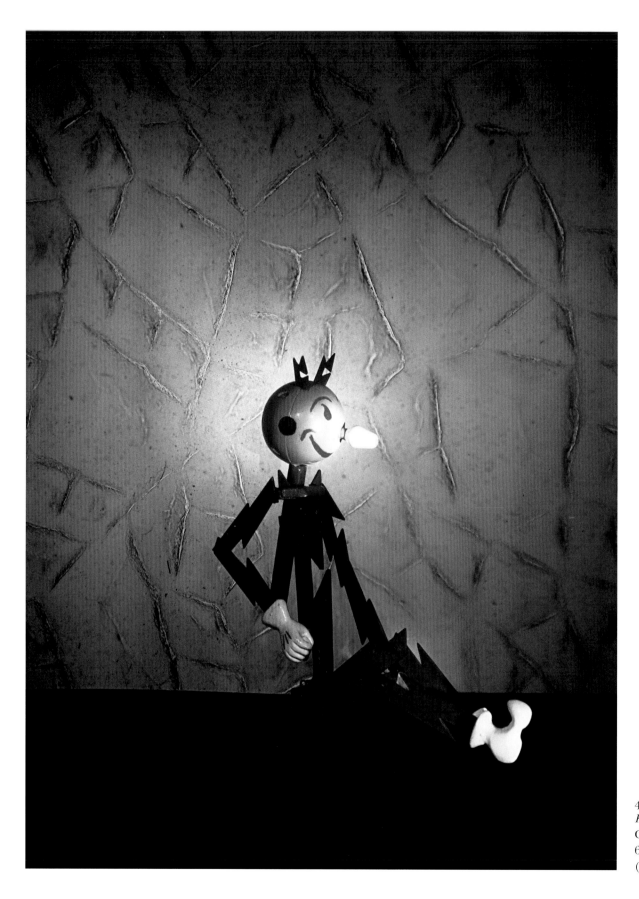

49. *Reddy Kilowatt*, 1988
Cibachrome print,
64 x 46 in.
(162.6 x 116.8 cm)

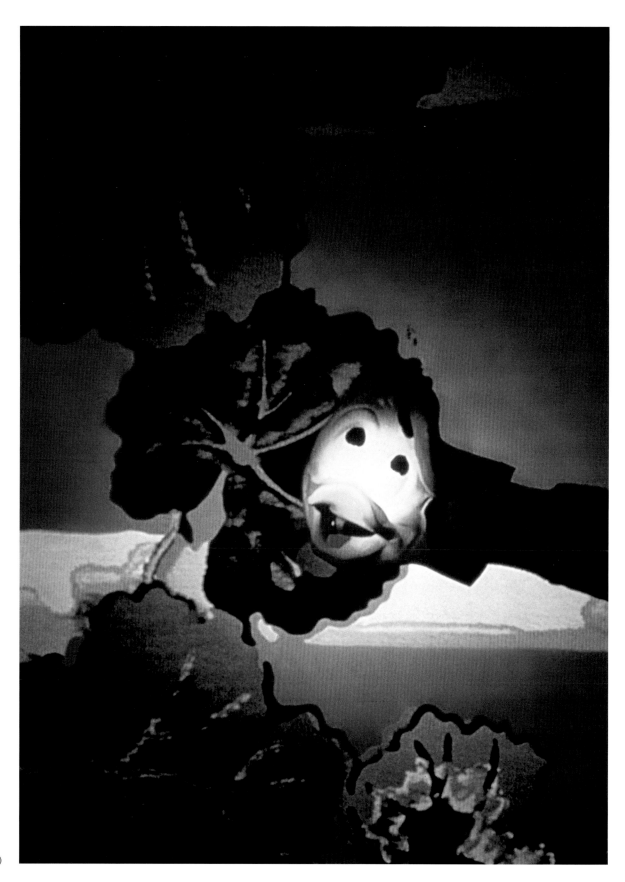

50. *Talking Duck Mitt*, 1988
Cibachrome print,
64 x 46 in.
(162.6 x 116.8 cm)

Things on Legs

There is inevitably an uncomfortable moment when one group of pictures is done and another has yet to begin. Though I enjoy the sense of completion, another part of me is open to messages about how to go forward.

One day, while visiting the ventriloquist Doug Skinner, I noticed a small black-and-white photo framed on his wall. It was a box of something like crackers or cookies on a pair of woman's legs. Very simple, just a box on legs. It jogged an early memory of a TV commercial in which cigarette packets were dancing across a stage in white majorette boots. That was barely a memory—more like a film loop—and I couldn't get it out of my mind. The memory was all mixed up with visions of synchronized swimmers and of the June Taylor dancers on *The Jackie Gleason Show*. They performed chorus-line routines reminiscent of Busby Berkeley film spectaculars. Jackie Gleason had developed this idea of overhead camera shots so that all sixteen dancers could be seen at once on a small TV screen. Their kaleidoscopic arm and leg movements became the show's trademark. And of course they dressed in sequins and lamé.

My high-school-best-friend's mother, a leggy redhead, was a former Rockette. Whenever she had a couple of drinks (which was fairly often), she tried to teach us how to kick. Her claim to fame was that once, when Fred Astaire passed through Radio City Music Hall, he'd noticed her and said "Hi, Red." As a result, she maintained her flaming red hair until the day she died.

Legs were haunting me. I think the dummy chatter had worn me out. Their conversations were in my brain, and I needed to go to a quieter place, one less cerebral and more physical. Dummies can't walk on their own. They need to be hoisted and carried like little children. Without a skilled ventriloquist to wake them up, they're absolute dead weight, the most inanimate of characters. In the early 1980s I'd taken many pictures of people and dolls underwater. I missed the grace and choreography of that time, particularly the peculiar kind of silence one experiences underwater.

I don't remember how I arrived at the idea of a camera on legs. I know the initial motivation was more symbolic and conceptual than visual. I was reading a lot at the time—Roland Barthes, Susan Sontag. My concept of the camera was changing, and becoming aware of its iconic, political, and psychological power was making me look at my own camera differently. It seemed less like a tool and more like a director. My camera was taking on a life of its own.

Some sequence of events led to my knowing that there was a camera character in the background of the movie *The Wiz*—a large hulking photojournalists' type box camera, complete with flash, wandering around on a man's body. Another set of coincidences led me to the Museum of the Moving Image in Queens, New York, where the camera had found a permanent post-movie home. After some negotiation, the museum agreed to let me borrow the camera for a day.

There was no doubt in my mind who my model would be. I asked my close friend, the photographer Jimmy DeSana, if he would mind wearing the camera contraption. He had been at times my neighbor, my mentor, my steady lunch date, and always my confidant. He always seemed to me like a real photographer because he'd studied photography at art school, whereas I, having had no formal photography training, always felt like a latecomer. I relied upon his expertise for photo and

lighting information, and in return I modeled for him whenever he needed a female character in his suburban psychosexual dramas.

In the summer of 1985 Jimmy was diagnosed with AIDS. By 1987 he was weakening, and it was not easy for him to stand up under the weight of the camera costume, but he really wanted to be in the picture. He was small and athletic and very proud of his legs. I'd bought him white tights and ballet shoes to wear with the camera, and he loved posing and seemed to enjoy the artist/model role reversal. I remember us both being aware that the picture was somehow important for our friendship, for our holding on to each other, and for my work. He loved being "Jimmy the Camera."

The subsequent shots were all objects placed on doll or mannequin legs, with the exception of the *Walking Purse* (plates 20 and 51) which was a human-size alligator purse modeled by my sister Bonnie. Initially I'd wanted all the objects to be worn by real people, but when I started to build a walking cake, I couldn't find a baker who would ice it for less than thousands of dollars. Though using doll and mannequin legs was a decision based on necessity and convenience, I loved taking those tiny figures and enlarging them to seven-foot-tall photographs. The legs in the original shots could be any size. My only rule was that they ended up as photographic prints that were as large as people.

What objects deserved to be anthropomorphized? That seemed like the easy part, and after awhile, things just presented themselves to me in obvious ways. A tiny plastic camera keychain from Times Square, a child's microscope, an old microphone, and masses of cakes and petits-fours. I got into a kind of punning game with myself, with woman-as-

cheesecake, the accordion-as-squeezebox, and the globe bending down (rather than Atlas supporting it in a macho way). It felt like assembling a cast of characters for a musical or repertory company. The tough part was finding legs to scale to the objects that found their way to me. I had a collection of plastic, ceramic, plaster, wooden, and metal legs in all shapes and sizes; eventually I started sawing legs off dolls.

I loved shooting these pictures and would probably still be finding new subjects today if I hadn't decided to impose an absolute finale. I took my favorite characters and lined them up for one last scene, or curtain call, and named the photo *Magnum Opus* (plate 22). I did everything but make them wave good-bye. In fact the picture is titled *Magnum Opus (The Bye-Bye)*.

When I finally printed the picture, it was over eight feet tall and twenty feet wide. My private joke about the making of a masterpiece was the biggest picture I'd ever made.

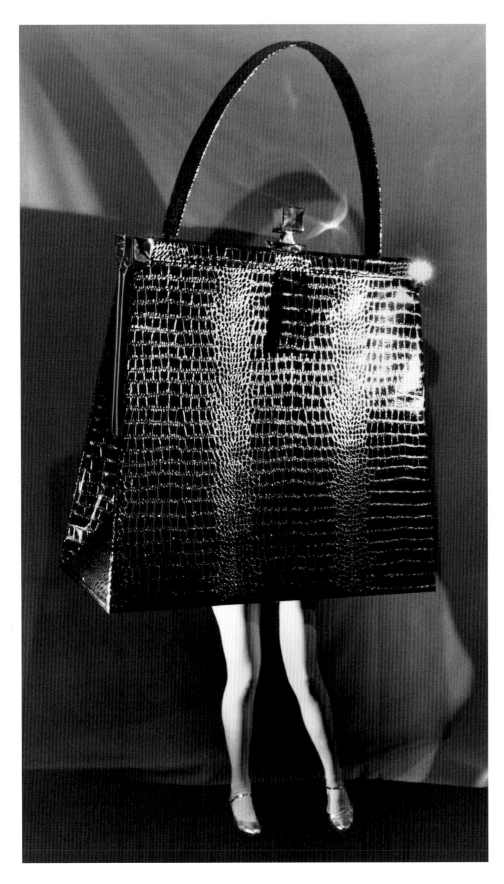

51. *Walking Purse*, 1989
Gelatin silver print,
84 x 48 in.
(213.4 x 121.9 cm)

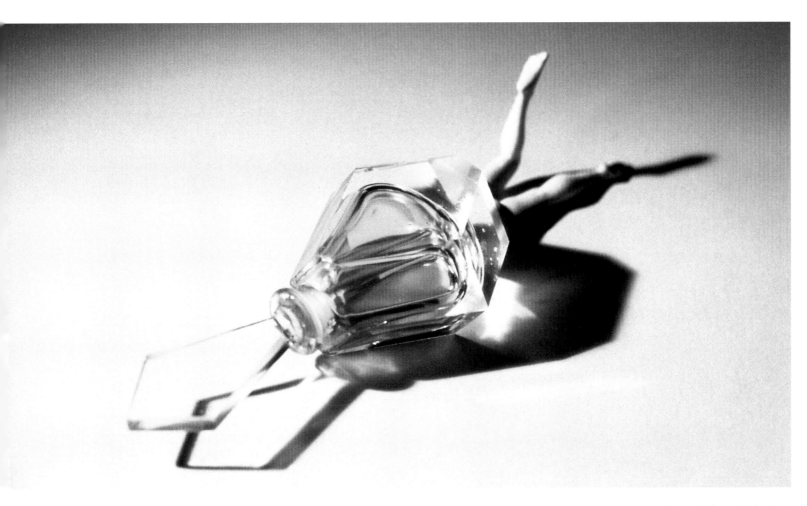

52. *Lying Perfume Bottle*, 1990
Cibachrome print,
48 x 84 in.
(121.9 x 213.4 cm)

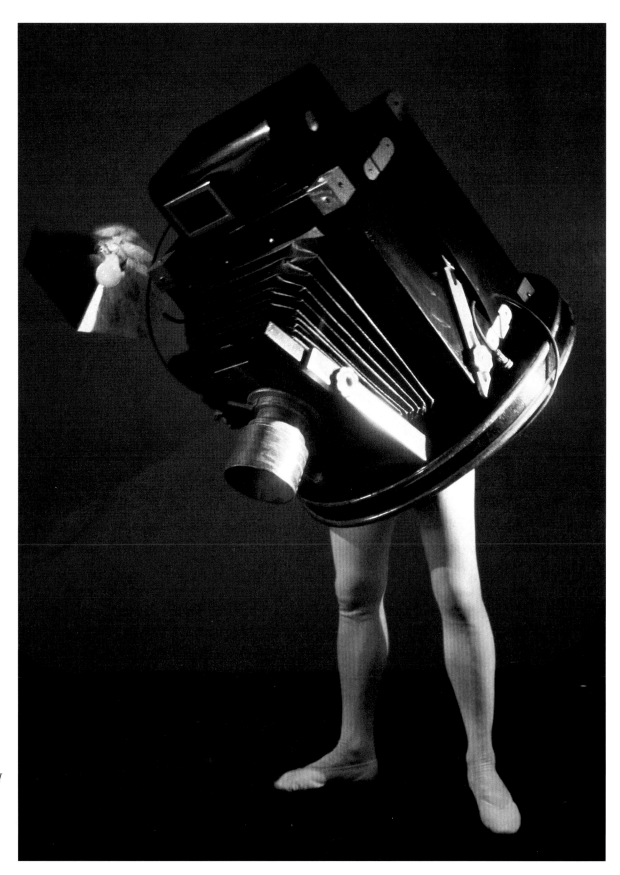

53. *Walking Camera I
(Jimmy the Camera/
Color)*, 1987
Cibachrome print,
64 x 46 in.
(162.6 x 116.8 cm)

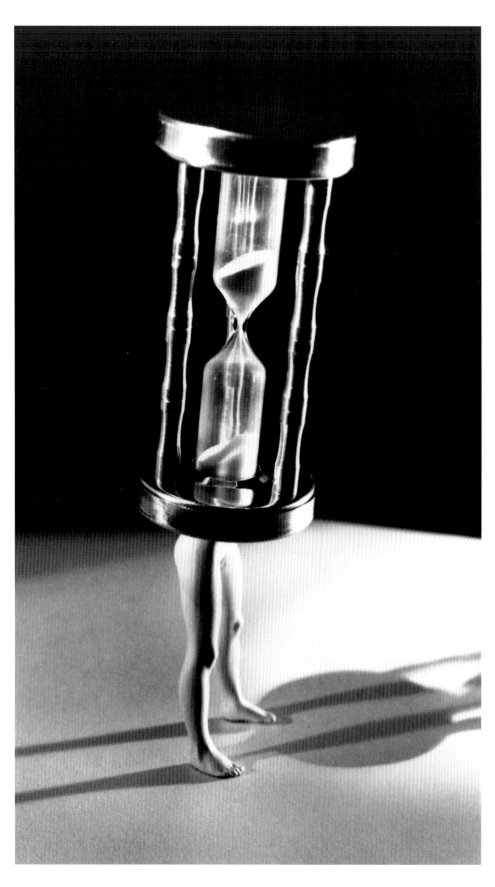

54. *Walking Hourglass*, 1989
Gelatin silver print,
84 x 48 in.
(213.4 x 121.9 cm)

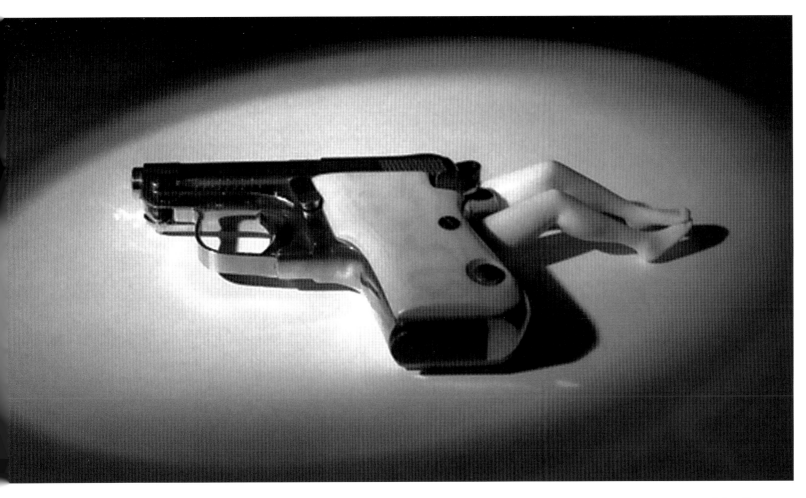

55. *Lying Gun,* 1990
Gelatin silver print,
48 x 84 in.
(121.9 x 213.4 cm)

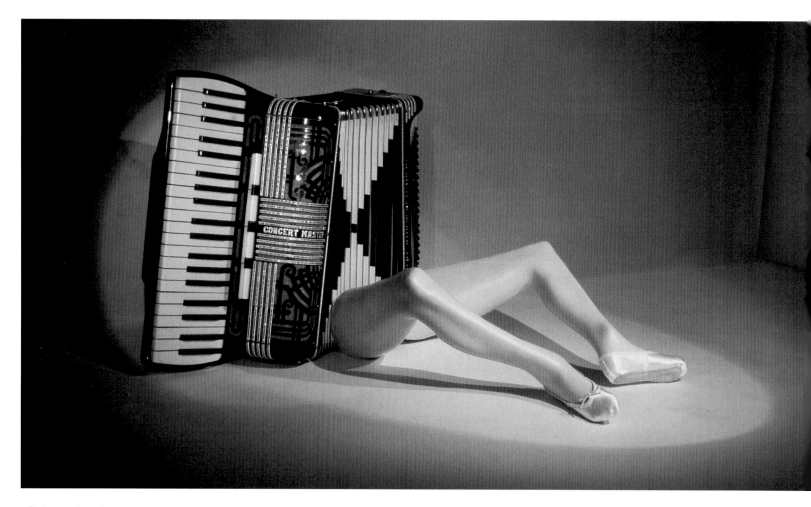

56. *Sitting Accordion*, 1991
Cibachrome print,
48 x 84 in.
(121.9 x 213.4 cm)

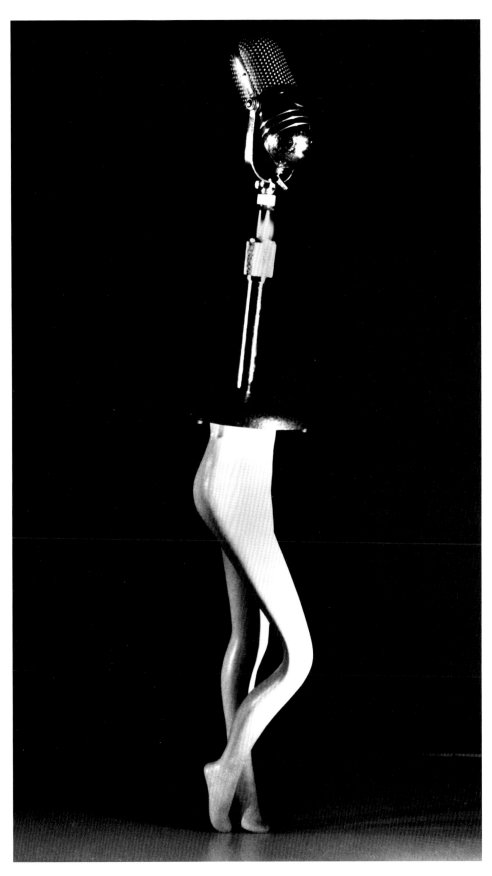

57. *Walking Microphone*, 1989
Gelatin silver print,
84 x 48 in.
(213.4 x 121.9 cm)

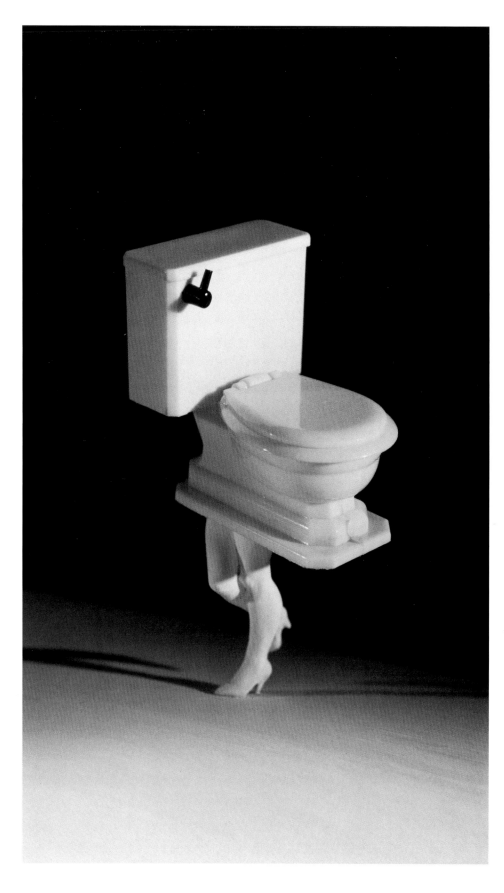

58. *Walking Toilet
(Color)*, 1989
Cibachrome print,
64 x 46 in.
(162.6 x 116.8 cm)

59. *Bending Globe*, 1991
Cibachrome print,
48 x 84 in.
(121.9 x 213.4 cm)

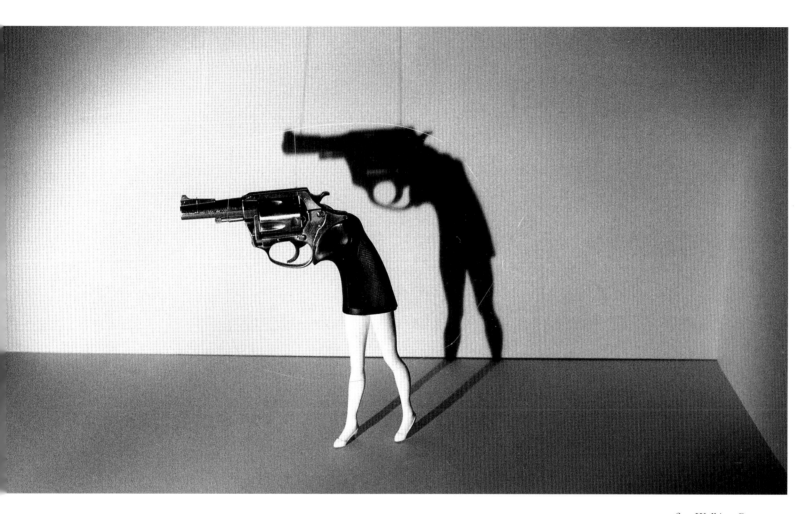

60. *Walking Gun,* 1991
Gelatin silver print,
48 x 84 in.
(121.9 x 213.4 cm)

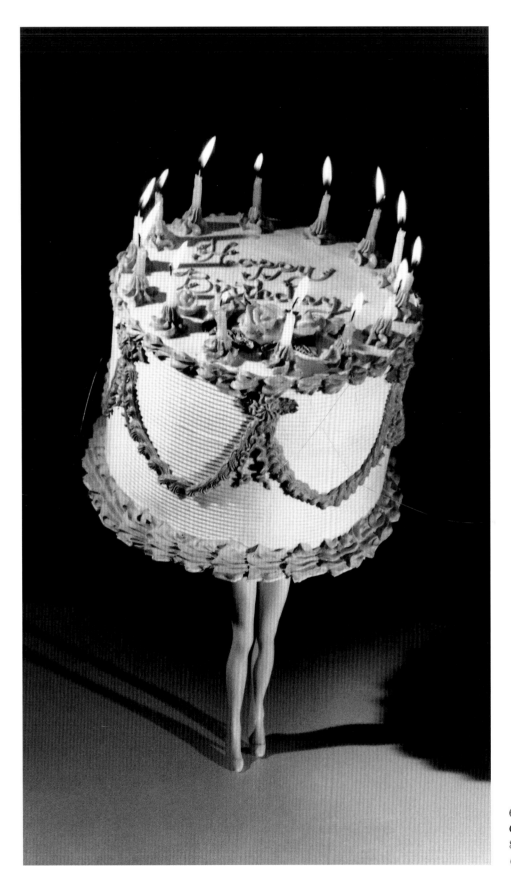

61. *Walking Cake*, 1989
Gelatin silver print,
84 x 48 in.
(213.4 x 121.9 cm)

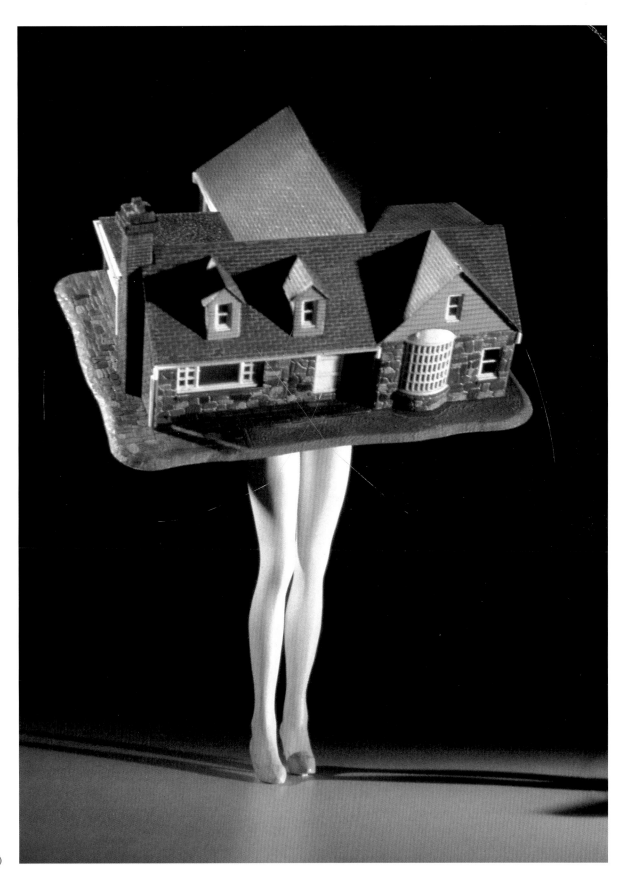

62. *Walking House
(Color)*, 1989
Cibachrome print,
64 x 46 in.
(162.6 x 116.8 cm)

63. *Four Petits-Fours*
(Studies for Walking Cake),
Yellow, 1989
Cibachrome print,
35 x 23 in.
(88.9 x 58.4 cm)

64. *Four Petits-Fours*
(Studies for Walking Cake),
Pink, 1989
Cibachrome print,
35 x 23 in.
(88.9 x 58.4 cm)

66. *Four Petits-Fours
(Studies for Walking Cake),
Lavender,* 1989
Cibachrome print,
35 x 23 in.
(88.9 x 58.4 cm)

67. *Lying Book*, 1990
Gelatin silver print,
48 x 84 in.
(121.9 x 213.4 cm)

68. *Sitting Microscope,* 1991
Gelatin silver print,
48 x 84 in.
(121.9 x 213.4 cm)

Little Men

I guess the book wasn't completely shut on ventriloquism. After *Magnum Opus (The Bye-Bye)*—the grand finale of the Walking Objects series—I once again had a nagging desire to examine men through my particular lens.

One thing that bothered me about my last attempt to photograph male characters was that my Vent Haven dummy project had been so visually stylized and odd. The figures I'd found at the museum were grotesque, primitive, cartoony, and in some cases insulting ethnic stereotypes. But my childhood recollection of ventriloquist dummies was of bland, generic fellows, well dressed and neatly coiffed—kind of smart-alecky Howdy Doody meets the collegiate good looks of Jerry Mahoney (Paul Winchell's dummy). I started searching for this character and realized that one option would be to build the guy myself. I found a ventriloquist and dummy maker named Alan Semok and worked with him for over a year to get the features just right. I made my first dummy with a movable mouth, giving him the potential to be part of an act. I'd found a perfect little set of child-sized dinner clothes and patent-leather dress pumps, which fit him perfectly. I had seven more dummies made (without movable mouths) so that I would have a cast of potential actors for photographs. I dragged a few of the dummies out to the beach on Long Island to work on romantic portraits in natural light (plate 78). I was absolutely mesmerized by the physicality of the characters I'd created.

I was reminded of an image that had made a deep impression on me years before. When I moved to a building in SoHo in 1973, I discovered that my neighbor on the top floor was a well-known French actor and a dwarf. He invited my roommate and me to his loft for a drink. When we arrived, he answered the door and, with a sort of bow and flourish, said, "I'd like you to meet my wife." He led us to the kitchen to meet a beautiful raven-haired woman of average height. He was only the second dwarf I'd ever met, and I was surprised by how tiny he actually was. We all sat down with goblets of red wine and began to chat. At a certain point his wife picked him up and lovingly sat him on her lap, like a child. The image was very powerful, a little shocking, a little sexy, and somewhat tender—kind of a Fellini-esque Madonna and Child. They seemed so comfortable in this exaggerated role reversal, where the woman was physically dominant and the boundary between man and boy became blurred.

I became very involved in dressing the dummies. I met a woman who had a small vintage clothing shop for children. She had beautiful tweed suits and navy blue jackets with gold buttons, madras shirts, khaki pants, and loafers with buckles. I became aware of the fact that boys used to dress like little men, not children; basically, the approach had been to shrink grown-ups' outfits, right down to the dark socks, suspenders, and neckties. I saw the dummies as little men, so this proved to be the ideal wardrobe solution. The fact that the figures were almost identical, with just slight variations of hair and eye color, made their sartorial differences all the more striking. My idea of the mid-century man was someone trapped by ambition and conformity, most probably based on the late night TV movie reruns I'd seen as a kid, like *The Man in the Gray Flannel Suit* and *Mr. Blandings Builds His Dream House.* I'd thought a lot about conformity when I was growing up. The way mothers and fathers looked, the way children looked, the way I was supposed to look. The first visible ex-

pression of a 1960s counterculture was long hair for men and the banishment of physically uncomfortable clothing: buttoned-up shirts, neckties, and heavy wool jackets for men, restrictive undergarments for women. My dummies defined their differences solely through their clothes. Their shirts were tucked in or shirttails were flying. They had string ties, bow ties, or patterned neckties. The slightest differences of color or pattern seemed to announce who they were or what they thought. That, combined with a subtle placement of a hand in a pocket or knee or ankle crosses, seemed to speak volumes.

At that time I had a collection of children's chairs, which appealed to me because they were both sculptural and toylike. I sat the dummies in the small chairs, and one chair in particular seemed a really good fit. I nailed that chair to the wall at eye level, secured the figure on it, and decided that the dummies could have a life outside my photographs— something I'd never tried before. Sets and props had always been just that—objects never seemed animated outside the viewfinder.

I named the dummy-sculpture *Clothes Make the Man*, and I had the chair copied seven times, so each dummy would have a place to sit. I arranged the group on a gallery wall. I didn't give the figures individual names, but rather titled them by a series of vaudevillian wisecracks like *Clothes Make the Man:* "don't I know it," "don't ask," "tell me about it," "you betcha," "you better believe it," and "ask any woman." I was exhibiting sculpture for the first time.

I did not, however, give up the idea of the figures as characters in a picture story. Imagining their wisecracks made me curious about their inner lives. Just as a ventriloquist could give them a voice, I decided that I could give them their thoughts.

Intrigued by the potential of the computer and Photoshop, I planned to drop thought bubbles into my pictures and make a photographic comic book. I called these pictures Café of the Inner Mind because I was making up both the inner and the outer life of my imagined characters.

I tried to invent male fantasies—not just regular guy fantasies, but those suitable for the dummy mind. I gathered images and ideas wherever I could: comic books; old porn magazines; car, motorcycle, and gun magazines. I really knew nothing about the true inner lives of my subject—but then again no one else really did either. I was free to make it all up.

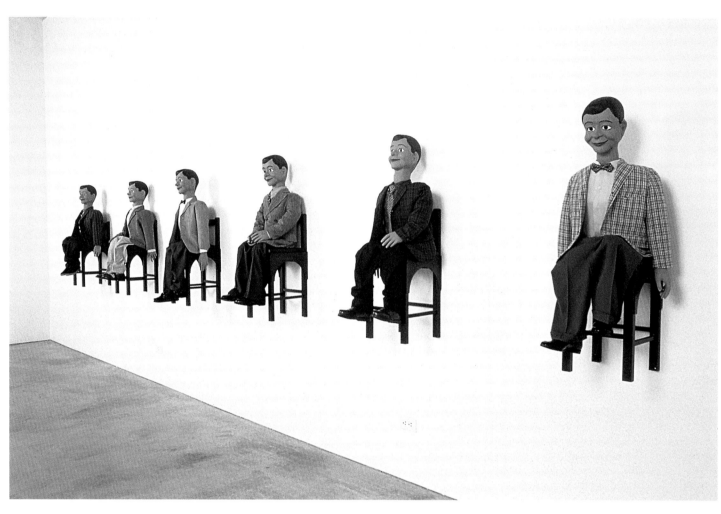

ABOVE:
69. Installation of Clothes Make
the Man at Daniel Weinberg
Gallery, Los Angeles, 1992

OPPOSITE:
70. *Clothes Make the Man
(ask any woman)*, 1992
Fiberglass, wood, nylon, and
clothing, 39 x 12 x 15 in.
(99.1 x 30.5 x 38.1 cm)

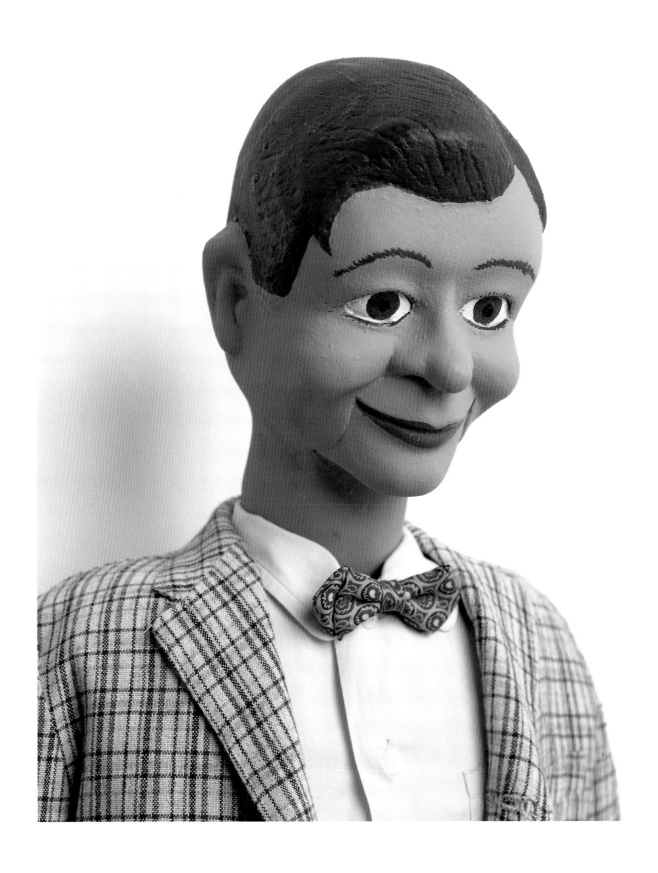

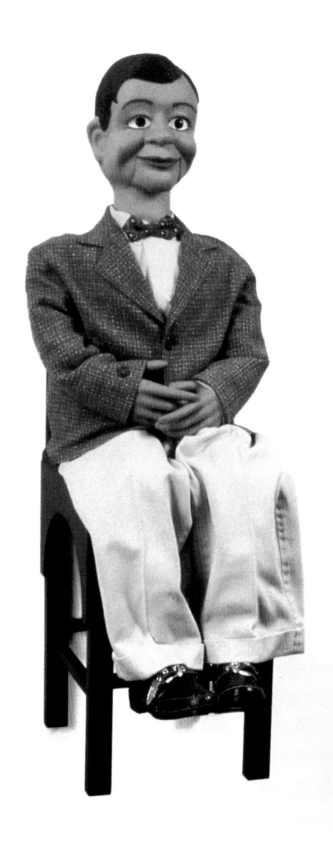

71. *Clothes Make the Man
(don't I know it)*, 1991
Fiberglass, wood,
nylon, and clothing,
39 x 12 x 15 in.
(99.1 x 30.5 x 38.1 cm)

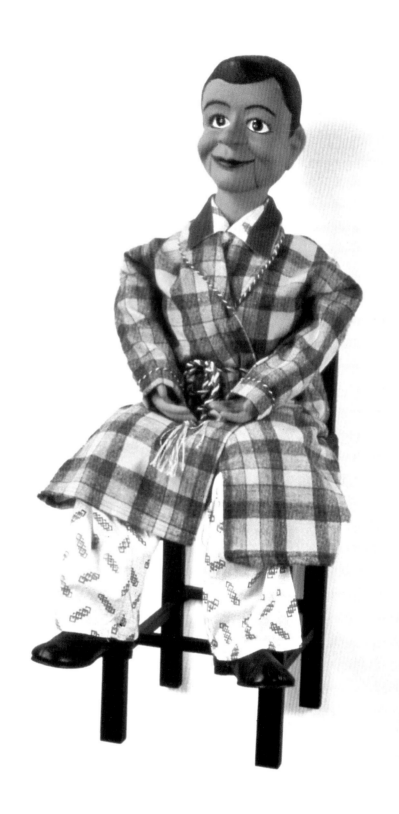

72. *Clothes Make the Man
(you better believe it)*, 1991
Fiberglass, wood,
nylon, and clothing,
39 x 12 x 15 in.
(99.1 x 30.5 x 38.1 cm)

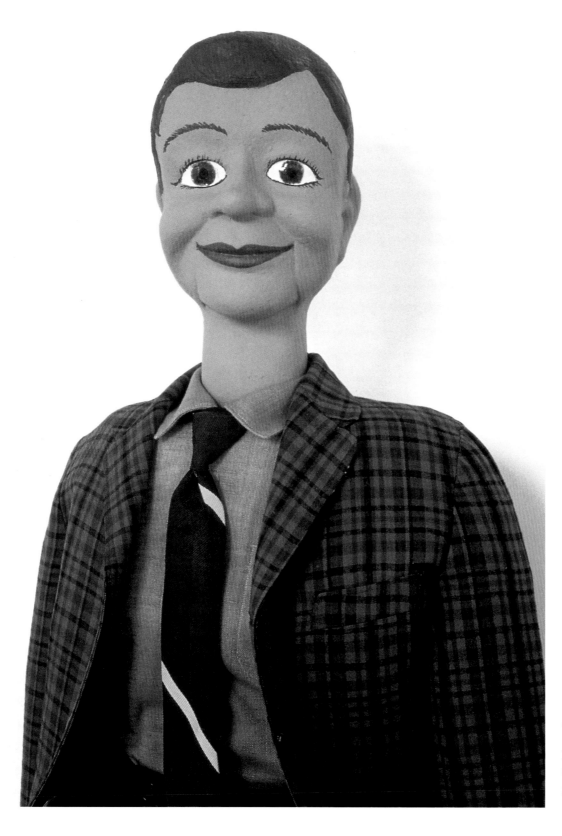

73. *Clothes Make the Man (don't ask)*, 1992
Fiberglass, wood,
nylon, and clothing,
39 x 12 x 15 in.
(99.1 x 30.5 x 38.1 cm)

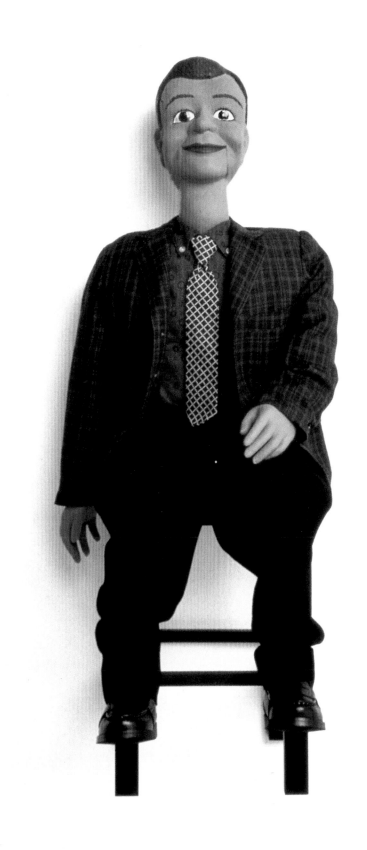

74. *Clothes Make the Man
(you betcha)*, 1992
Fiberglass, wood,
nylon, and clothing,
39 x 12 x 15 in.
(99.1 x 30.5 x 38.1 cm)

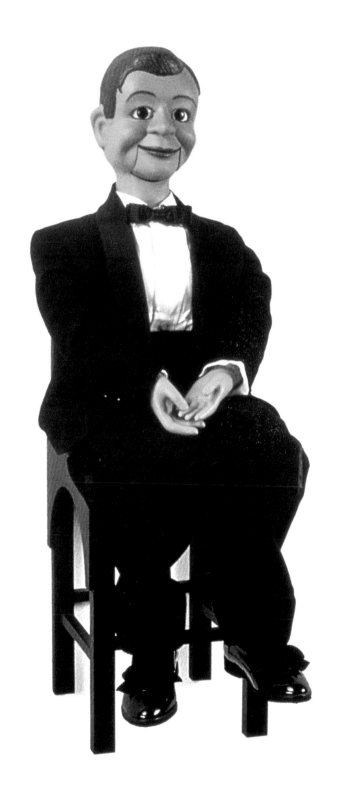

75. *Clothes Make the Man
(and I should know)*, 1991
Fiberglass, wood, nylon,
and clothing,
39 x 12 x 15 in.
(99.1 x 30.5 x 38.1 cm)

NEXT SPREAD:
76. Installation of Clothes
Make the Man at Daniel
Weinberg Gallery,
Los Angeles, 1992

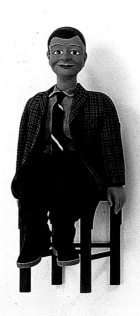
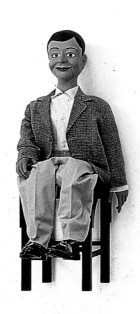
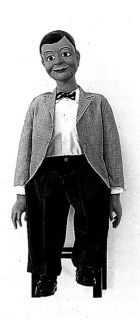

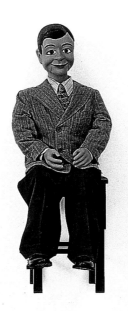
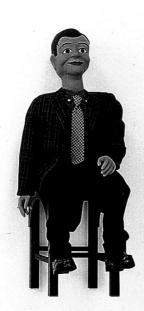
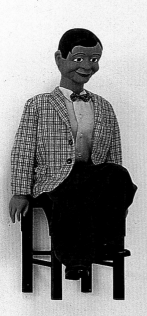

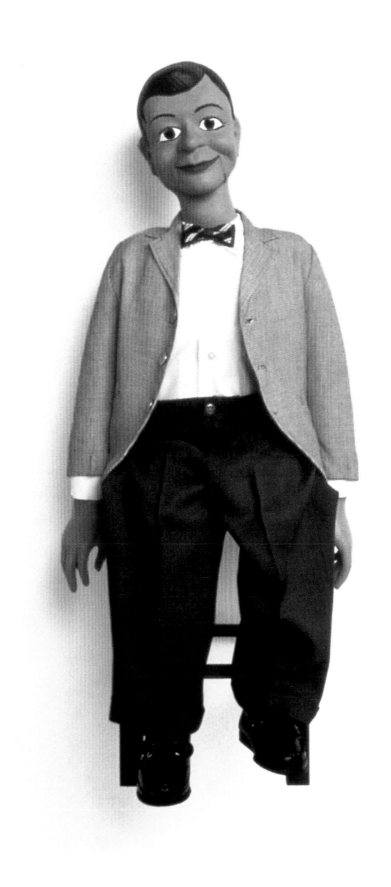

77. *Clothes Make the Man*
(tell me about it), 1992
Fiberglass, wood,
nylon, and clothing,
39 x 12 x 15 in.
(99.1 x 30.5 x 38.1 cm)

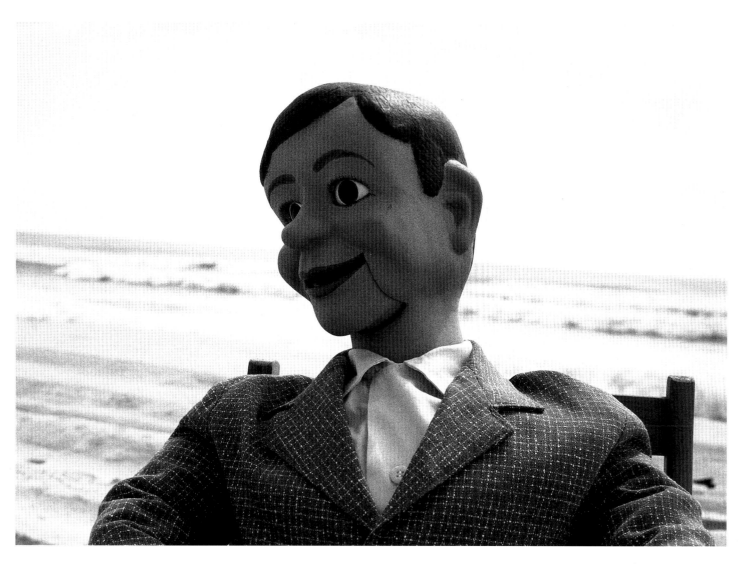

78. *Untitled Dummy/
Beach II*, 1990
Gelatin silver print,
19½ x 27 in.
(49.5 x 68.6 cm)

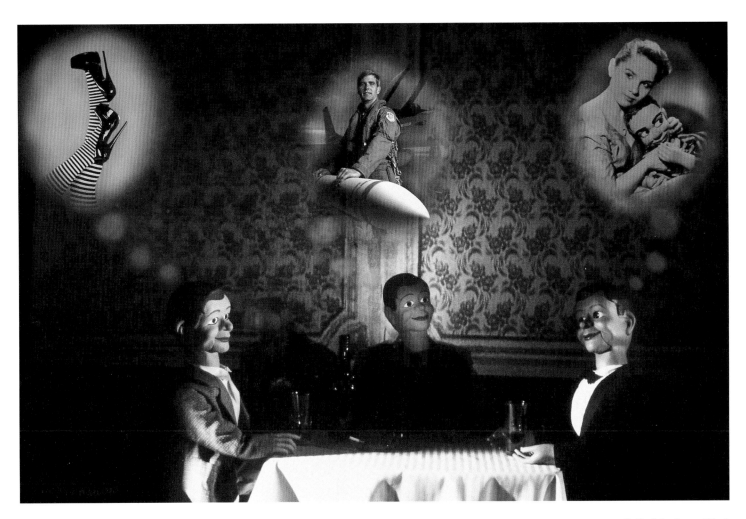

79. *Café of the Inner Mind:*
Gold Café, 1994
Cibachrome print,
35 x 53 in.
(88.9 x 134.6 cm)

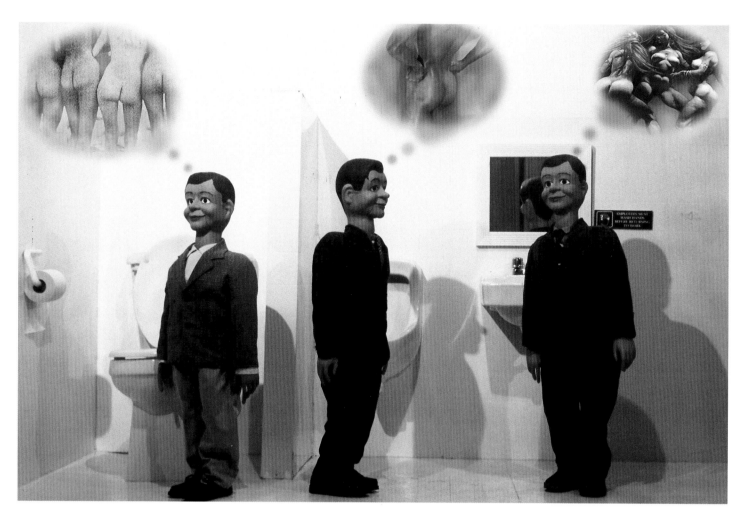

80. *Café of the Inner Mind:*
Men's Room, 1994
Cibachrome print,
35 x 53 in.
(88.9 x 134.6 cm)

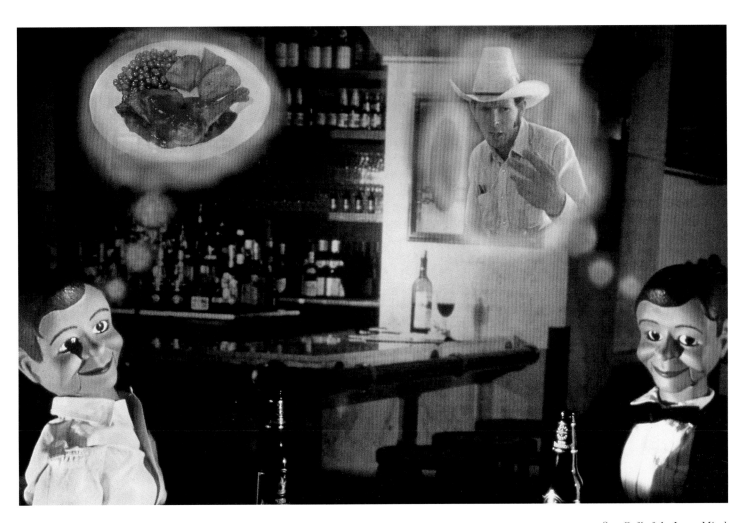

81. *Café of the Inner Mind:*
Chicken Dinner, 1994
Cibachrome print,
35 x 53 in.
(88.9 x 134.6 cm)

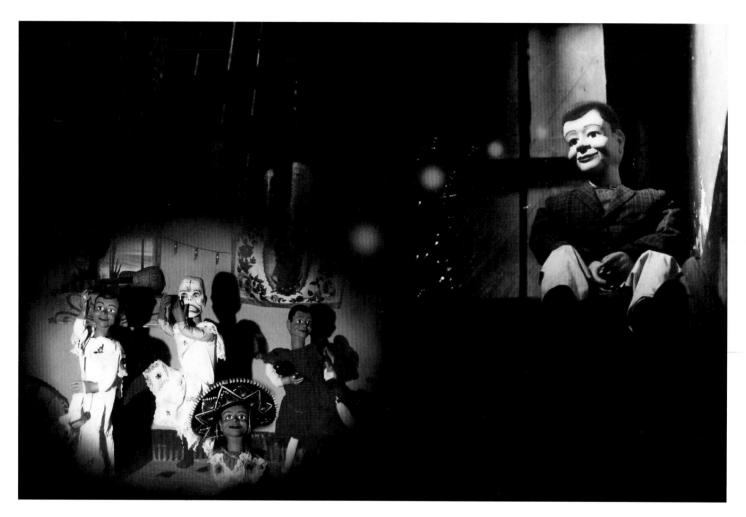

82. *Café of the Inner Mind:*
Mexico, 1994
Cibachrome print,
35 x 53 in.
(88.9 x 134.6 cm)

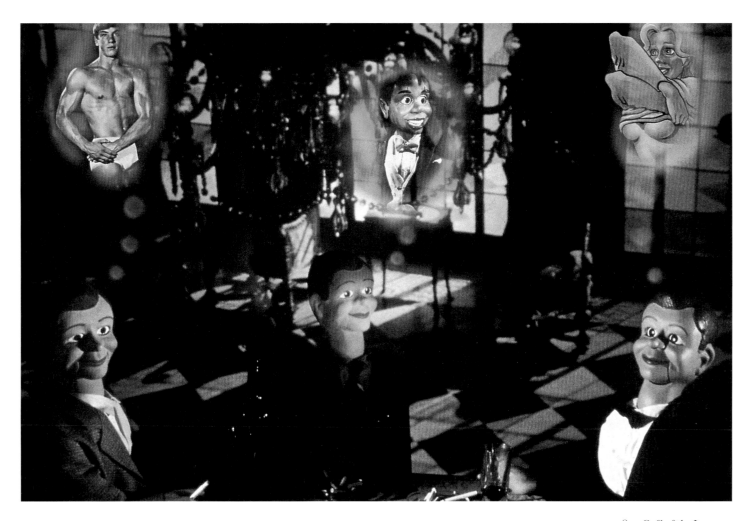

83. *Café of the Inner Mind: Dark Café*, 1994
Cibachrome print,
35 x 53 in.
(88.9 x 134.6 cm)

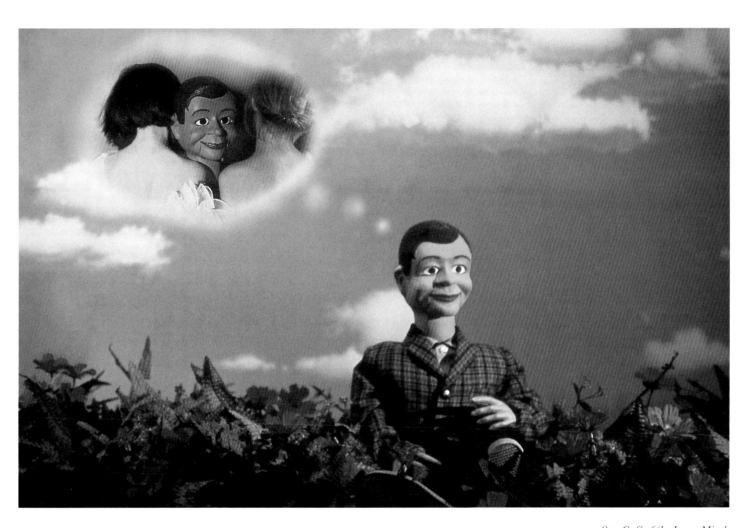

84. *Café of the Inner Mind:*
Caroline's Field, 1994
Cibachrome print,
35 x 53 in.
(88.9 x 134.6 cm)

Me, Myself, and I

I spent a lot of time thinking about being a muse. To be the inspiration seemed as important as being inspired—or perhaps even more so. In those days the subtle societal messages that penetrated a little girl's daydreams made her pretend to be a nurse, not a doctor, and a stewardess, not a pilot. In our neighborhood-wide game of Rin Tin Tin, the plum role of Lt. Rip Masters was always taken by the boys. The best part I ever played was one of my own invention: a hawk that flew around in circles. This enabled me to view the proceedings from above, rather than play the lieutenant's girlfriend, which was a sideline part, at best.

I myself never had a muse, nor am I aware of ever having been one. Even though I had posed for endless hours in Jimmy DeSana's psychosexual photographic dramas, I always had the sense that, as his best friend and neighbor, I was more a convenient body than the inspiration for his stories. When it came time to design a girl dummy, I refused to give the part to anyone but myself. I liked the idea of my own image inspiring myself. I'd noticed at the Vent Haven Museum a tendency toward twinning. Dummies were designed in the image of their vent or the two of them simply wore identical suits or caps. There were a number of photographs of female vents posing with miniature versions of themselves. My particular favorite was a pair of girls in matching wigs and pinafores looking in a mirror. Twins times two.

In 1993 I contacted the same ventriloquist who had made my little men, and I sent him a bunch of Polaroids of my face and hair. He produced a female figure who resembled me so completely that her shadow in profile was virtually indistinguishable from mine. I photographed her over and over, but it was her shadow that ended up haunting me far more than her face. I dressed her in my favorite sweater and jewelry and paired her with a guy dummy in a series titled The Music of Regret. These were the first pictures I ever made about love, and their kind of cornball musical theater ambience made it possible for me to deal with the subject matter. She became more real and more animated each time I photographed her, as I learned what kinds of tricks the light and shadows could play.

With her movable eyes (rare in ventriloquists' dummies), I felt she was staring at me from every angle—like the *Mona Lisa*. As a child I'd been taken to the Metropolitan Museum of Art to view the *Mona Lisa*, which was on loan from the French government and hung behind bulletproof glass. We waited on line for hours for our turn to look, and the only things I was told to notice were her enigmatic smile and how she would seem to be looking at me no matter where I stood. It was way too crowded to see the painting from more than one angle, and I was at a loss as to what else to notice. In the end, Leonardo's masterpiece seemed far too small to warrant all this attention.

I especially liked posing the girl dummy in the center of all the boy dummies. She seemed to bask in the glow of their undivided attention while maintaining a somewhat bemused but coy expression. Unlike me, she was utterly comfortable with so many pairs of eyes gazing directly at her. I believed the dummy maker had infused her character with more than a touch of the coquette.

I'd always had the fantasy of inhabiting my own images: walking through the milky light of my toy bathrooms, say, or living in the magazine world of my Color-Coordinated Interiors. I attribute this longing to my having wanted, as a child, to enter the space of

a storybook. The books I remember having read to me had lusciously watercolored landscapes and loosely rendered but friendly children. The space on the page had an inviting depth and light, and I was frustrated I couldn't get in there.

In 1997, almost twenty years after I'd made my first set-up photos, I invented a small figure in my likeness who could step into my pictures. I'd found a beautiful black-and-white-model of a bathroom that had been used as a window display in a plumbing-fixture store. I cut a diamond-shaped hole in the wall so the sun could make the same shadow and light as in my original pictures (see plate 15). I placed the set-up (with the model of me) in front of the same window with the same morning light where I'd photographed the blue bathrooms years before. When I looked through my viewfinder at myself through the window, I felt as though one story was finally over.

From there it was easy to start having different heads made in my image by different sculptors. I was almost more curious about the results of the artists' attempts to capture my likeness than I was about the heads themselves. The sculpted heads resembled me to varying degrees, ranging from insulting to pass-able. I never ultimately got what I wanted, but the challenge of finding the one angle or the one facial feature that looked like me to me kept me shooting. My favorite head was mounted on a stick, remind-ing me of the talking walking sticks I'd found at Vent Haven. I hung a party dress on this construction and photographed it in front of a plywood wall in a huge ramshackle cottage we rented on a lake in Connecticut (plate 92).

I also commissioned a Neapolitan sculptor to make a huge angel with my face, sculpted in the style of the angels on the Christmas tree at the Metropolitan Museum. I shot it hanging on the front porch of our lake house, with only a smoke machine and the summer night sky as a backdrop (plate 93). My favorite picture is called *Midlake* (plate 95). My assistant swam out into the lake and held the stick underwater, so that only the head and hair showed above water—reminding me of the home movies my father had shot of my sisters and me swimming in a lake in Maine. Just heads and hair or colorful bathing caps bobbing up and down on the surface of the water. I also thought particularly about Harry Callahan's *Eleanor*, *Chicago*, *1949*, head above water, eyes closed. I later found out that Paul Strand had rented the same lake house in 1916 and shot his Twin Lakes photos there, from the front porch.

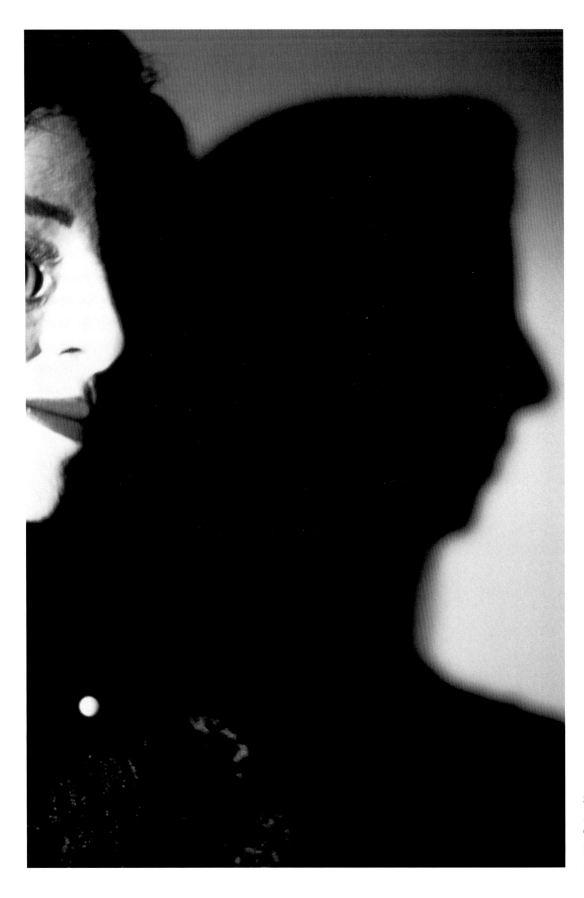

85. *The Music of Regret XII*, 1994
Cibachrome print,
23½ x 15½ in.
(59.7 x 39.4 cm)

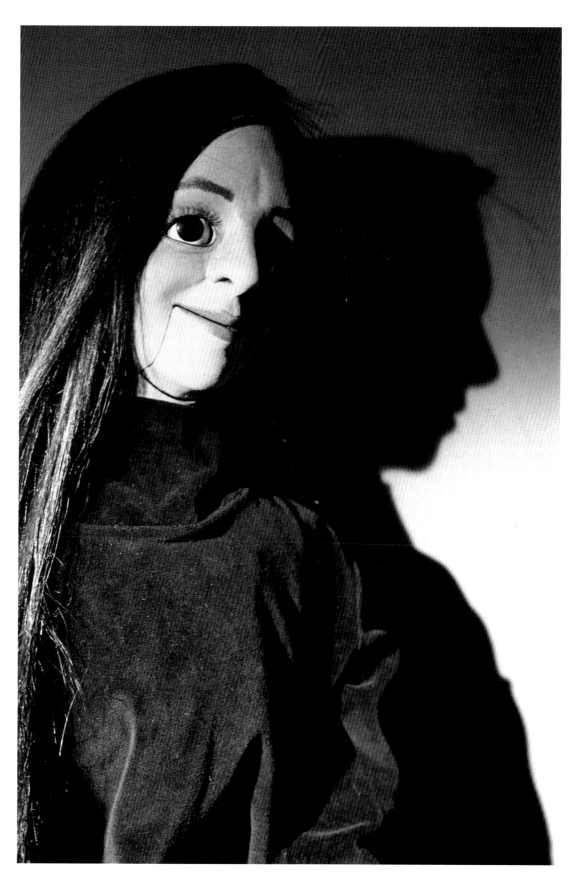

86. *The Music of Regret I*, 1994
Gelatin silver print,
23½ x 15½ in.
(59.7 x 39.4 cm)

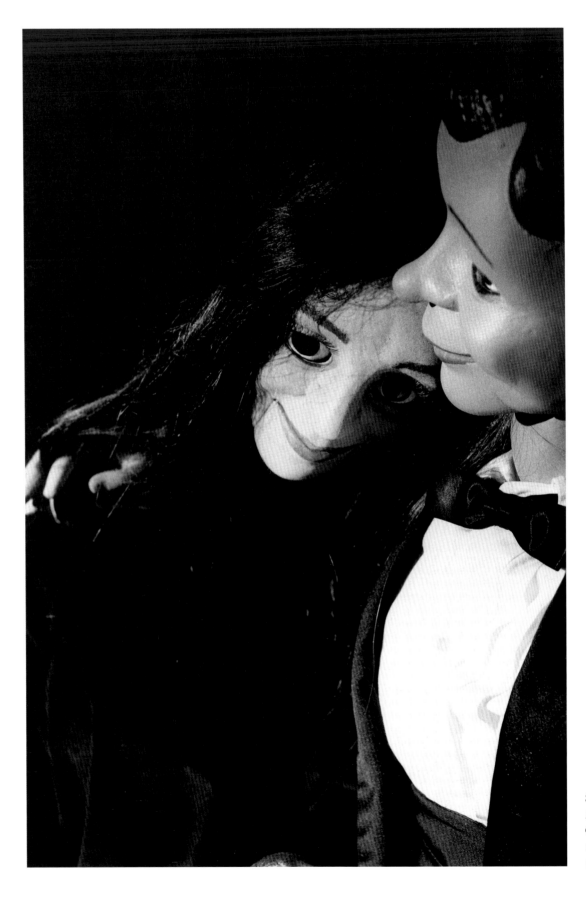

87. *The Music of Regret II*, 1994
Gelatin silver print,
23¹⁄₂ x 15¹⁄₂ in.
(59.7 x 39.4 cm)

88. *The Music of Regret XIII,* 1994
Gelatin silver print,
19½ x 19½ in.
(49.5 x 49.5 cm)

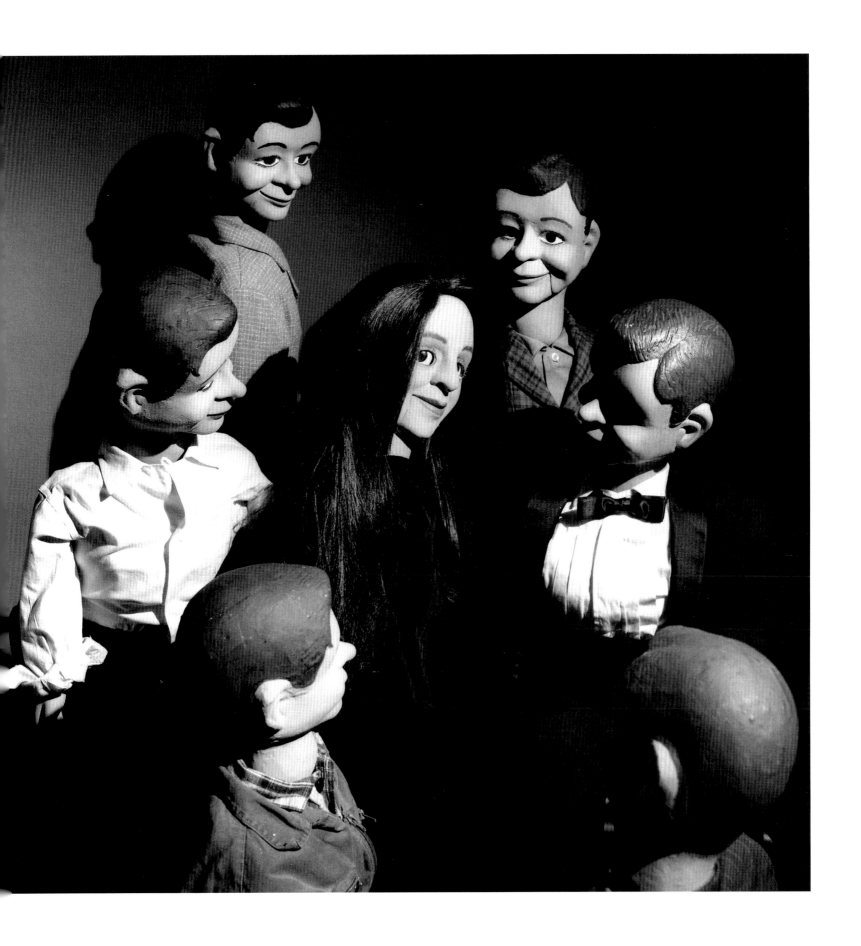

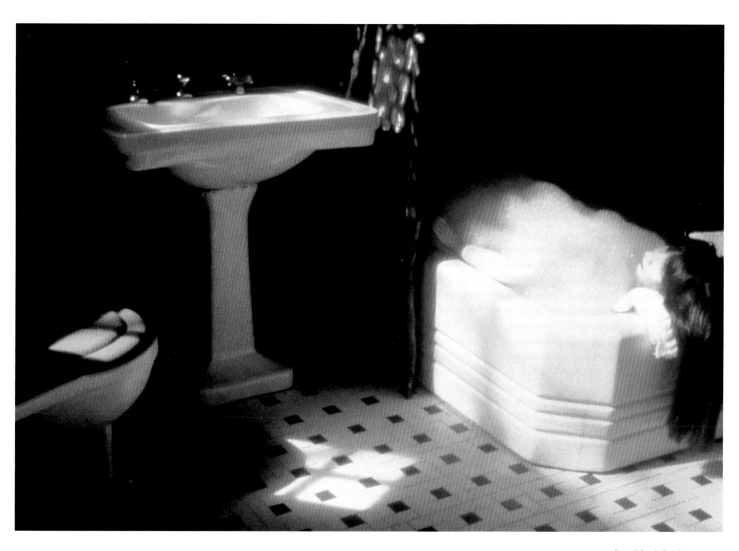

89. *Black Bathroom*
(April 16, 1997), 1997
Cibachrome print,
28 x 40 in.
(71.1 x 101.6 cm)

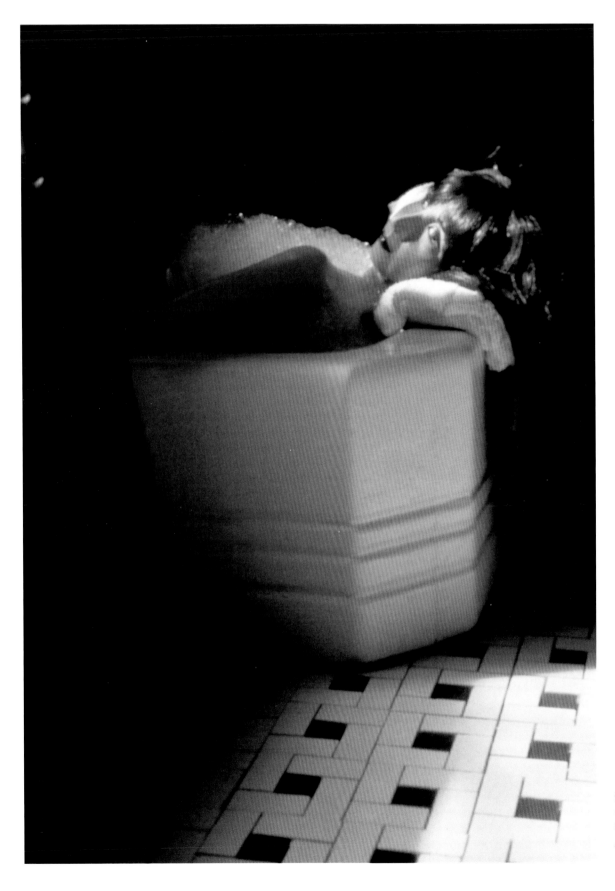

90. *Black Bathroom (Detail)*, 1997
Cibachrome print,
40 x 28 in.
(101.6 x 71.1 cm)

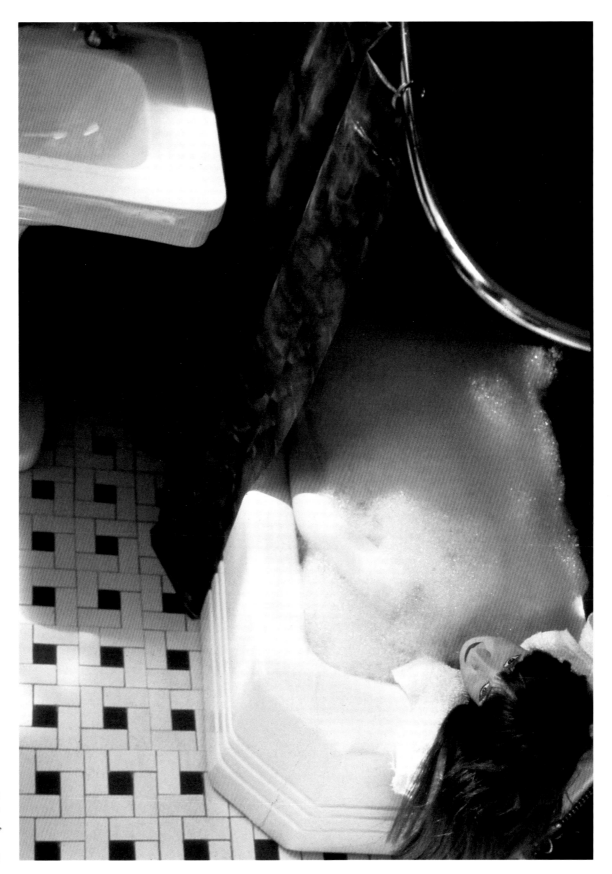

91. *Black Bathroom
(Aerial View)*, 1997
Cibachrome print,
40 x 28 in.
(101.6 x 71.1 cm)

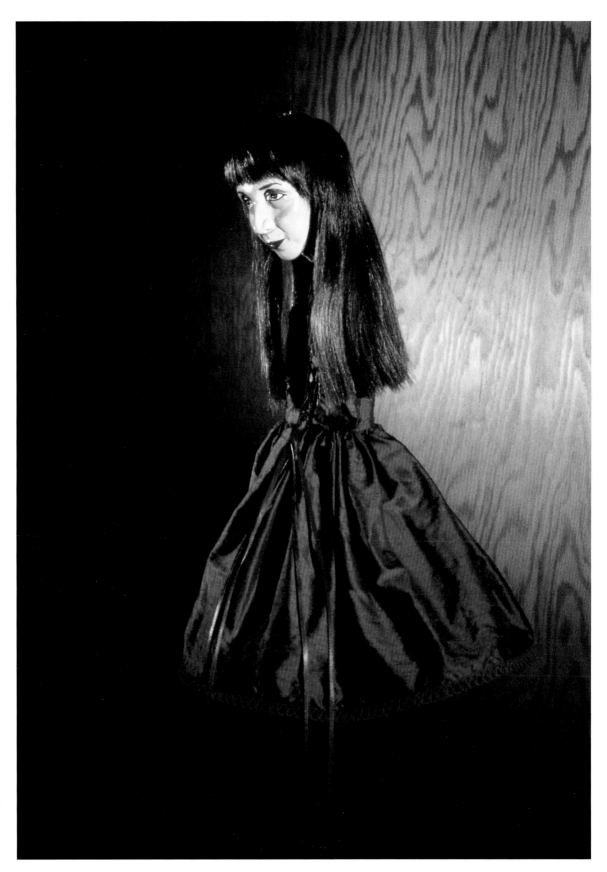

92. *Party Dress
(Three-Quarter View)*, 1997
Cibachrome print,
40 x 28 in.
(101.6 x 71.1 cm)

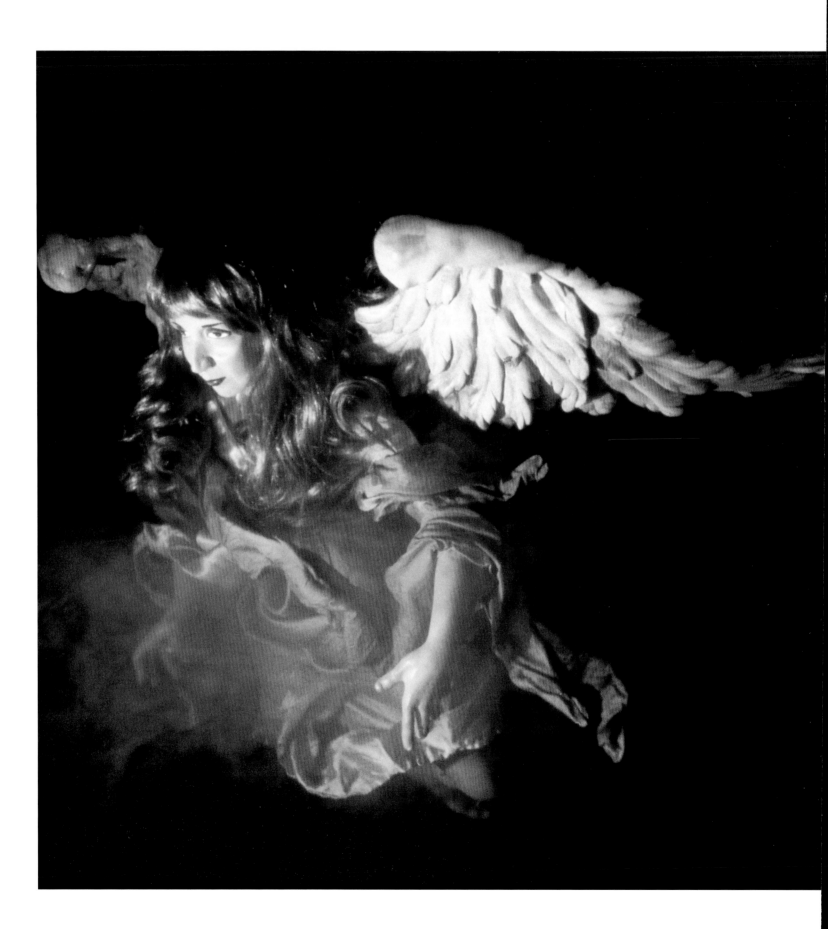

93. *Angel (Flying Left)*, 1997
Cibachrome print,
28 x 40 in.
(71.1 x 101.6 cm)

94. *Lake (Night View)*, 1997
Cibachrome print,
28 x 40 in.
(71.1 x 101.6 cm)

95. *Midlake*, 1997
Cibachrome print,
28 x 40 in.
(71.1 x 101.6 cm)

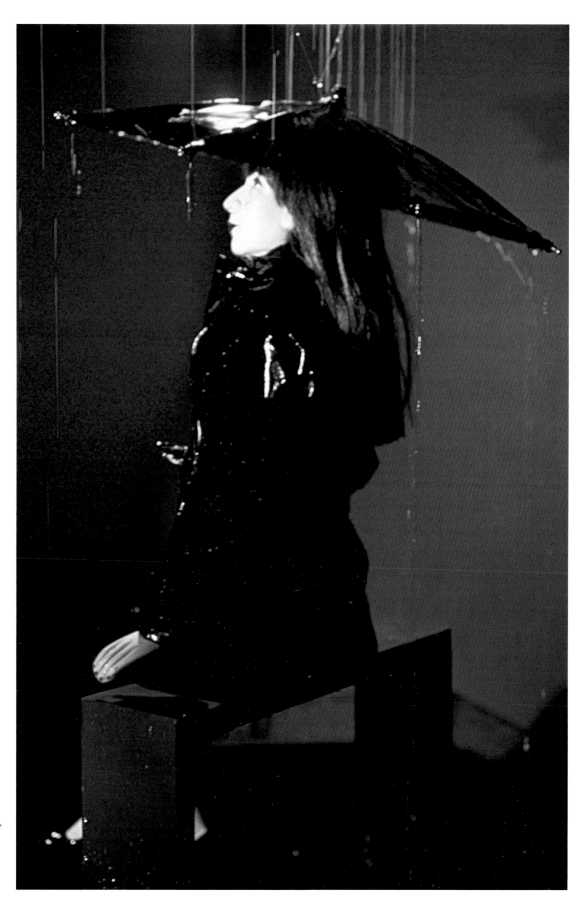

96. *The Umbrellas
of Cherbourg*, 1996
Mixed-media installation,
dimensions site-specific
Installation at
Postmasters Gallery,
New York, 1996

Chronology

<table>
<tr><td>1949</td><td>October 3—born on Long Island, New York, to Samuel I. Simmons, a dentist, and Dorothy Trussel Simmons, a housewife.</td></tr>
<tr><td>1956</td><td>Receives first camera—a Brownie—from her father.</td></tr>
<tr><td>1969–70</td><td>Studies at the Tyler School of Art program in Rome. Discovers early Renaissance painting (Giotto, Cimabue, Duccio, and Piero della Francesca), which later inspires her first dollhouse interiors in color.</td></tr>
<tr><td>1971</td><td>Graduates from the Tyler School of Art, Philadelphia, with a BFA.

Lives with a group of friends on a farm in upstate New York (until 1973).

Buys twenty-year-old toys (still in their original packages) from a toy store in Liberty, New York, that is going out of business; later uses these in the Interiors series of 1976–79.</td></tr>
<tr><td>1972</td><td>Tours Europe, including Eastern Europe, and Turkey by car for seven months.

Sets up first crude darkroom to print photographs shot in Romania and Bulgaria.</td></tr>
<tr><td>1973</td><td>Moves to New York City; shares a loft on Broadway in SoHo with Jimmy DeSana, who becomes her photographic mentor.</td></tr>
<tr><td>1975</td><td>Makes first photographic artwork, using the toys bought in Liberty, New York.</td></tr>
<tr><td>1977</td><td>Meets painter Carroll Dunham. He gives her the 35 mm Nikon he had used in high school for a workshop with Minor White.</td></tr>
<tr><td>1979</td><td>Has first one-person exhibition, at Artists Space, New York. Included in first group exhibition, *Photographie als Kunst*, Innsbruck Museum, Innsbruck, Austria.

Dunham gives her a group of toy cowboys, which become the subject of her second one-person exhibition, at P.S. 1 in Queens, New York.</td></tr>
<tr><td>1980</td><td>Is given an underwater camera that had belonged to *Time-Life* photographer Dean Brown by his widow, Carol Brown. Starts shooting underwater.</td></tr>
<tr><td>1980–2000</td><td>Represented by Metro Pictures Gallery, New York.</td></tr>
<tr><td>1981</td><td>Travels to Montego Bay, Jamaica, with a group of friends to shoot underwater for her first one-person exhibition at Metro Pictures Gallery, titled *Water Ballet*.</td></tr>
<tr><td>1983</td><td>Marries Carroll Dunham.</td></tr>
<tr><td>1984</td><td>Exhibits Tourism series at International with Monument in the East Village, New York.

Awarded National Endowment for the Arts Grant.</td></tr>
<tr><td>1985</td><td>Collaborates with the artist Allan McCollum on Actual Photos—a series of portraits of HO- and Z-scale train figures, photographed through a microscope at the pathology laboratory at Memorial Sloan-Kettering Cancer Center, New York.</td></tr>
</table>

1986	Daughter Lena Dunham is born.
1987	Makes first trip to the Vent Haven Museum in Fort Mitchell, Kentucky, to shoot ventriloquists' dummies and memorabilia.
	Borrows life-size camera (a movie prop from *The Wiz*) from the Museum of the Moving Image in Queens and shoots DeSana wearing it for the photograph *Walking Camera (Jimmy the Camera)*—the first in her Walking and Lying Objects series.
1989	Designs a male dummy and hires the ventriloquist Alan Semok to fabricate first it, then a group of almost identical male dummies, and finally a dummy in her own image.
1990	Jimmy DeSana dies of AIDS.
1992	Daughter Grace Simonoff Dunham is born.
	The Museum of Modern Art, New York, acquires *Walking House*, twelve works from the Actual Photos series, and four additional photographs.
1995–2005	Summers—rents White Lodge, an old hotel in Twin Lakes, Connecticut, and shoots all of her self-portraits there.
1995	Actual Photos series is shown at Nature Morte Gallery in the East Village.
1997	Receives John Simon Guggenheim Memorial Fellowship.
	Retrospective, *The Music of Regret*, is held at the Baltimore Museum of Art. For the cover of the catalog, she shoots a photograph of a doll in her image posed in a black bathroom.
2000	With architect Peter Wheelwright, creates Kaleidoscope House for Bozart Toys—a modernist dollhouse sold at the Museum of Modern Art store and elsewhere.
2001	Receives as a gift *The Instant Decorator* (1976), by Frances Joslin Gold. A how-to decorating guide, the book becomes the basis of a series by the same name.
2003	Joins Sperone Westwater Gallery, New York.
2004	Shows The Instant Decorator series at Sperone Westwater.
	At an antique show in New York City, discovers miniature dioramas made during the 1940s by the Eastern European artist Ardis Vinklers. They become the source material for her series The Boxes.
2005	Starts work on her first film project—a puppet musical.
	March–May—awarded the Roy Lichtenstein Residency in the Visual Arts at the American Academy in Rome.

Series

Public Collections

Albright-Knox Art Gallery, Buffalo, New York

Allen Memorial Art Museum, Oberlin, Ohio

The Baltimore Museum of Art

The Birmingham Museum of Art, Birmingham, Alabama

The Corcoran Gallery of Art, Washington, D.C.

Fogg Art Museum, Harvard University, Cambridge, Massachusetts

The Hara Museum, Tokyo

High Museum of Art, Atlanta

International Center of Photography, New York

The Israel Museum, Jerusalem

Los Angeles County Museum of Art

The Metropolitan Museum of Art, New York

Musée d'Art Contemporain, Montreal

Museum of Contemporary Art, Los Angeles

Museum of Fine Arts, Houston

The Museum of Modern Art, New York

Philadelphia Museum of Art

The Saint Louis Art Museum

The Solomon R. Guggenheim Museum, New York

Stedelijk Museum, Amsterdam

Walker Art Center, Minneapolis

Weatherspoon Art Museum, University of North Carolina, Greensboro

Whitney Museum of American Art, New York

Selected Bibliography

Books and Catalogs

Cameron, Dan. *Laurie Simmons*. San Jose, Calif.: San Jose Museum of Art, 1990.

Celant, Germano, Kate Linker, Lars Nittve, and Craig Owens. *Implosion: A Postmodern Perspective*. Stockholm: Moderna Museet, 1987.

Elger, Deitmar, and Luise Horn. *McCollum/Simmons: Actual Photos*. Ostfildern, Germany: Cantz Verlag, 1995.

Galassi, Peter. *Pleasures and Terrors of Domestic Comfort*. New York: Museum of Modern Art, 1991.

Goldwater, Marge. *Past/Imperfect: Eric Fischl, Vernon Fisher, Laurie Simmons*. Minneapolis: Walker Art Center, 1986.

Grundberg, Andy, and Kathleen McCarthy Gauss. *Photography and Art: Interactions since 1946*. Fort Lauderdale Museum of Art and Los Angeles County Museum of Art; New York: Abbeville Press, 1986.

Heiferman, Marvin, and Lisa Phillips. *Image World: Art and Media Culture*. New York: Whitney Museum of American Art, 1989.

Heiferman, Marvin, and Joseph Jacobs. *This Is Not a Photograph: Twenty Years of Large-Scale Photography 1966-1986*. Sarasota, Fla.: John and Mable Ringling Museum of Art, 1987.

Howard, Jan. *Laurie Simmons: The Music of Regret*. Baltimore: Baltimore Museum of Art, 1997.

Hoy, Anne H. *Fabrications: Staged, Altered, and Appropriated Photographs*. New York: Abbeville Press, 1987.

Jones, Ronald. *Laurie Simmons*. Cologne: Jablonka Galerie, 1989.

Kelley, Mike, ed. *The Uncanny*. Arnhem, The Netherlands: Gemeentemuseum, 1993.

Lahs-Gonzales, Olivia, and Lucy Lippard. *Defining Eye: Women Photographers of the 20th Century*. Saint Louis: Saint Louis Art Museum, 1997.

Marien, Mary Warner. *Photography: A Cultural History*, pp. 441–42. London: Laurence King Publishing, 2002.

Marincola, Paula. *Image Scavengers: Photography*. Philadelphia: Institute of Contemporary Art, 1982.

Murphy, Angela Kramer, and Eugenie Tsai. *Playtime: Artists and Toys*. Stamford, Conn.: Whitney Museum of American Art at Champion, 1995.

Relyea, Lane, and Connie Fitzsimmons. *Remembrances of Things Past*. Long Beach, Calif.: Long Beach Museum of Art, 1986.

Rosen, Randy, and Catherine C. Brawer. *Making Their Mark: Women Artists Move into the Mainstream, 1970-85*. New York: Abbeville Press, 1989.

Schorr, Collier. *Laurie Simmons: Photographs 1978/79*. New York: Skarstedt Fine Art, 2002.

Storr, Robert. "Laurie Simmons." In *Disparities & Deformations: Our Grotesque*, pp. 122–23. Santa Fe: SITE Santa Fe, 2004.

Weintraub, Linda. "Laurie Simmons." In *Art on the Edge and Over: Searching for Art's Meaning in Contemporary Society, 1970s–1990s*, pp. 34–38. Litchfield, Conn.: Art Insights, 1996.

Interviews, Writings, and Projects by Laurie Simmons

1987 *Laurie Simmons: Water Ballet/Family Collision.* Minneapolis: Walker Art Center, 1987.

Simmons, Laurie. "Ventriloquism." *Artforum* 26 (December 1987): 93–99.

1994 *Laurie Simmons.* Interview by Sarah Charlesworth. New York: A.R.T. Press, 1994.

Simmons, Laurie. "The Perfect Companion." *New York Times Magazine,* December 11, 1994, pp. 88–91.

1996 Sabbag, Robert. "The Invisible Family." Photographs by Laurie Simmons. *New York Times Magazine,* February 11, 1996, pp. 32–39.

"The Next Hundred Years." Photographs by Laurie Simmons. *New York Times Magazine,* September 26, 1996, p. 186.

Yablonsky, Linda. "Laurie Simmons." Interview in *BOMB* 57 (Fall 1996): 18–23.

1997 Simmons, Laurie. "Toys Are Us: Jarvis Rockwell in His Studio." *Artforum* 36 (October 1997): 82–87.

1998 "Isaac Mizrahi with Laurie Simmons." *Index* 2 (January–February 1998): 20–29.

1999 Howard, Maureen. "A House without Dolls." Photographs by Laurie Simmons. *Nest: A Quarterly of Interiors* 7 (Winter 1999–2000): 153–65.

2000 "Laurie Simmons: A House without Dolls." Winner of the 2000 Alfred Eisenstaedt Award. *Life,* Spring 2000, p. 53.

"Beauty 101: Laurie Simmons Searches the Web for the Perfect Shade." *Index* 5 (September–October 2000): 81–85.

Wheelwright, Peter. "Peek-a-boo Views." Photographs by Laurie Simmons. *Nest: A Quarterly of Interiors* 10 (Fall 2000): 120–33.

Viladas, Pilar. "Welcome to the Dollhouse." Photographs by Laurie Simmons. *New York Times Home Design Magazine,* Fall 2000, part 2, p. 50.

"Claude Sabbah with Laurie Simmons." *Index* 5 (November–December 2000): 41–47.

2001 Simmons, Laurie. "Ice Hotel." *Index* 5 (April–May 2001): 113–15.

2002 "Laurie Simmons: Top Ten." *Artforum* 40 (February 2002): 35.

"A. M. Homes with Laurie Simmons." *Index* 7 (September–October 2002): 48–53.

Simmons, Laurie. *Hammer Projects: Karen Yasinsky.* Los Angeles: Hammer Museum, 2002.

2003 Viladas, Pilar. "The Antidecorator." *New York Times Home Design Magazine,* April 13, 2003, pp. 76–79.

Simmons, Laurie. "Guys and Dolls: The Art of Morton Bartlett." *Artforum* 42 (September 2003): 204–7, 261.

Squiers, Carol, and Laurie Simmons. *Laurie Simmons: In and Around the House, Photographs 1976–78.* New York: Carolina Nitsch Editions, 2003.

2004 Richards, Judith Olch, ed. "Laurie Simmons, 7 March 1994." In *Inside the Studio: Two Decades of Talks with Artists in New York,* pp. 138–41. New York: Independent Curators International (ICI), 2004.

Index

Page references in *italic* refer to illustrations.

Acknowledgments

I'd like to thank Ellen Harris, executive director of Aperture Foundation, whose initial approach brought this book into being; Kate Linker, whose brilliant, thoughtful essay determined the scope of the book; Bettina Bruning, my studio manager, who has painstakingly organized my archives and been an invaluable source of good advice for the last ten years; Francesca Richer, for her serene nature and equally serene design sense; Lisa Farmer, for her production savvy; Angela Westwater and Sperone Westwater, for their support of Aperture Foundation and of me throughout this process; and my editor, Nancy Grubb, for her focus, her spectacularly skillful attention to detail, her innate understanding of my work, and her wicked sense of humor. —LAURIE SIMMONS

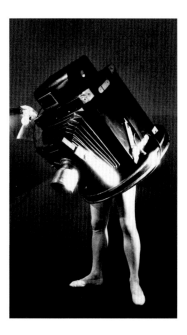

LAURIE SIMMONS was born on Long Island and earned a BFA from the Tyler School of Art, Philadelphia. Her photographs have appeared in a multitude of international exhibitions, and she is represented in numerous private and public collections. Simmons lives and works in Manhattan.

KATE LINKER is a Manhattan-based independent critic and scholar who has written extensively on contemporary art. Her previous books include *Love for Sale: The Words and Pictures of Barbara Kruger* and *Vito Acconci*.